THE ART INSTITUTE OF PORTLAND

Ellen Harvey

New York Beautification Project

GREGORY R. MILLER & CO.

Published in 2005 by Gregory R. Miller & Co., New York

Gregory R. Miller & Co., LLC
62 Cooper Square
New York, New York 10003

Book design, including jacket and cover: Jan Baracz
Photographs: Jan Baracz (jacket, cover and pp. 9, 13, 15, 17, 19, 21, 23, 25, 27, 29, 31, 33, 35, 37, 39, 41, 43, 45, 47, 49, 51, 53, 55, 57, 59, 61, 63, 65, 67, 69, 71, 73, 75, 77, 79, 81, 83, 85, 91)

Photographs: Ellen Harvey (pp. 7, 11, 87, 93)

Artist photograph: Brooke Williams

Printed and bound in China

Available through D.A.P./Distributed Art Publishers
155 Sixth Avenue, 2nd Floor
New York, New York 10013
Tel: (212) 627-1999
Fax: (212) 627-9484

Library of Congress Cataloging-in-Publication Data

Harvey, Ellen, 1967–
New York beautification project / Ellen Harvey.
p. cm.
ISBN 0–9743648–1–9
1. Harvey, Ellen, 1967 — Catalogs. 2. Mural painting and decoration — New York (State) — New York — Catalogs. 3. Site-specific art — New York (State) — New York — Catalogs. 4. Landscape in art — Catalogs. 5. Street life — Anecdotes. I. Title.
ND237.H34357A4 2005
759.13 — dc22

B+T - NW/HE

for Thom

The New York Beautification Project consisted of forty oval landscape paintings in oils that I painted directly onto existing graffiti sites throughout New York City, without permission, from the summer of 1999 to the early spring of 2001. Each painting was approximately five by seven inches in size. I discontinued painting and scraped off the paintings whenever anyone objected to them.

The following photographs and text document all the paintings that were completed, or almost completed.

My apologies to all the graffiti artists whose work I was unable to credit because I didn't know their names. I did my best to find them.

Ellen Harvey, 2005

Concrete pylon in Highbridge Park at 181st Street and Amsterdam Avenue, Washington Heights, Manhattan

June 1999

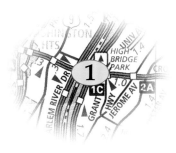

This is how it started. Mayday Productions, which was a group of curators and artists, asked me to do a piece for "Parking," a one-day art event in Highbridge Park next to the East River, which was being organized by Laurie De Chiara. The park had just been renovated by the New York Restoration Project, and the event was supposed to persuade the community that it was safe to use the park again. It had been a pretty scary place. While clearing away all the stripped, stolen cars, the volunteers had even found a human torso in a bag. The volunteers were very romantic about the park, though. They kept on pointing out how beautiful it was.

I'm a painter, and this was the first time anyone had asked me to do anything outdoors, so I thought I'd better paint something. I bought a lot of horribly expensive gold paint and painted all the vandalized lampposts in the park gold. My friends helped.

Because I finished early with the lampposts, I thought I would paint some graffiti to add to all the existing graffiti. I spent two days painting a little oval landscape over a graffiti tag on one of the highway overpass pillars. I had never painted a landscape before, so I stole the background from Nicolas Poussin's *Landscape with Diogenes*. I thought a classical landscape would be a nice reflection of the park's aspirations. It also seemed like a good tag for a white European painter like me.

The park was quite busy. On the first day, a man masturbated in the bushes opposite me for what seemed like an improbably long time. Then a boy came by and asked what I was doing. I showed him and he said, "Man, that's a good job — how'd you get a job like that?" He then asked me how much I was paid, and when I said that I was doing it for free, he said, "Man, you've got to get a better job." The second day, a teenage couple came by and looked at the painting and said that it was *"muy romantico"* and then went into the bushes together. Fortunately, the man from the day before wasn't there anymore. A lot of art people came to the show. There weren't many people from the neighborhood except for the park regulars, who looked a bit surprised.

I don't know who "ARD" is, but he or she later tagged the painting with a very small "ARD" in magic marker. I went back to take a photograph of the mini-tag, but my boyfriend Thom and I got mugged by a teenage boy. He claimed to have a gun, but we couldn't see it. Despite the invisible gun, we gave him $15, which made him go away. He didn't take my camera, but I decided not to stick around to take a photograph. I don't know if this painting is still there or not, since I've not gone back.

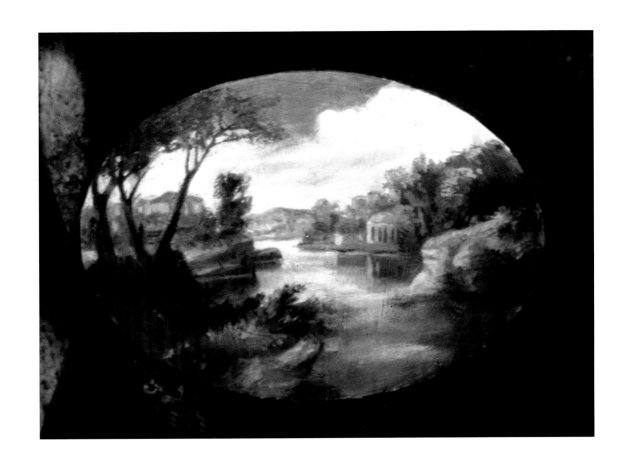

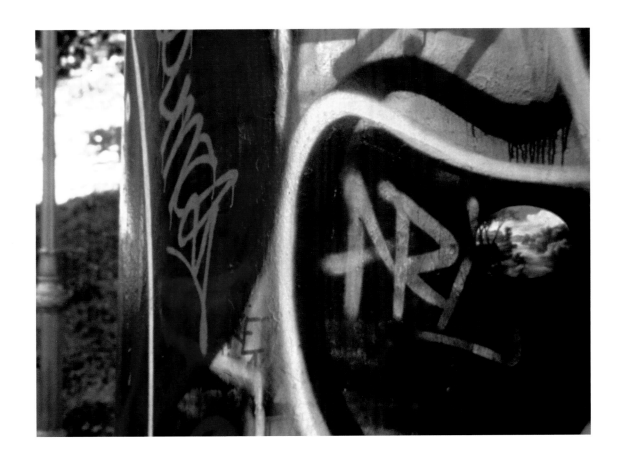

Dumpster at 111 North 10th Street, Williamsburg, Brooklyn

March 2000

After I made the first painting, I wanted to keep going. So I thought that I would do a hundred.

I decided to paint only on sites that already had graffiti and where I didn't have permission, and that I would erase the paintings whenever anyone objected. And since most of the city's official beautification projects involved planting flowers or trees or somehow bringing nature into the city, I decided to call my landscapes the New York Beautification Project, which was a very grand title for a project that consisted of myself and a paintbrush. It took me a while to get started, because I was nervous about my new career as a vandal and because other things kept getting in the way. I'm a bit of a procrastinator.

This painting was on a dumpster near my studio. While I was working, one of the women from the bakery upstairs came by and said, "It's just like a postcard." I think it was meant as a compliment, but I'm not sure. Oddly enough, the painting was based on a postcard of an American painting. I lost the postcard, so now I no longer know whose painting I copied. I think it may have been by Albert Bierstadt.

The dumpster is gone now. Our building replaced Waste Management with Bestway Carting for our trash needs.

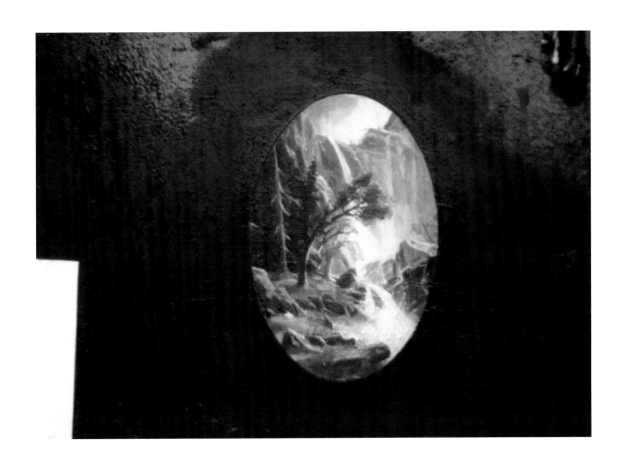

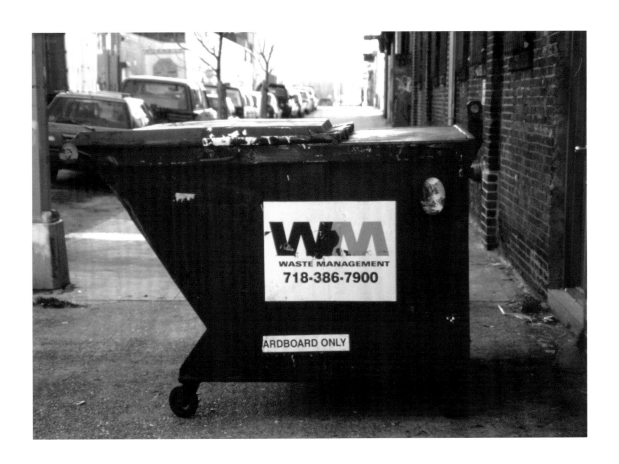

This wall is just opposite the Bronx River Art Center, where my friend Karen Jones was curating a show called "Environmentally Concerned II." There are a lot of murals all around the area, but this one is especially good. It was made by a group of artists led by someone called "Ezo." My painting was on a section of the mural that had been left unfinished. It was based on one of those nebulous Claude Lorrain classical scenes. Because I changed it quite a bit, I can't figure out which one it was anymore.

People started coming up to me as soon as I started, probably because I didn't look much as if I belonged to the neighborhood. A lot of people asked me if I was from Manhattan. When I told one girl that I was from Brooklyn, she said, "I have a cousin in Brooklyn." She made Brooklyn sound a very long way away.

At the beginning of the second day, a boy came up to me and asked, "Are you doing that with respect?" I said that I was and he said, "Good, because if you weren't, I'd have a problem with that. But I can see that you're doing it with respect." It was a good thing that he felt that way, because it turned out that I was painting on his brother's section of the mural. His brother hadn't finished it because he was too busy with his other commissions. My new acquaintance was worried about my graffiti career: "You're doing it all wrong. It's too small. You can't even see it from a car. It takes too long. You're never going to get anywhere like this." His brother had a "dot com" now, he said, and was making good money painting signs for local merchants. He was also very concerned that I didn't have a crew, so he stayed around for the rest of the day, keeping a lookout for the police. When he left, he said he'd send his cousin to look out for me, but he never came. I never figured out who his brother was. I got Ezo's phone number from the Bronx River Art Center and sent him images to get the names of the artists who painted that section, but he never responded.

Late in the day, an old couple from Puerto Rico came by and said, "Finally, a good picture of Puerto Rico." The last time I called the Bronx River Art Center, they told me that the painting was still there.

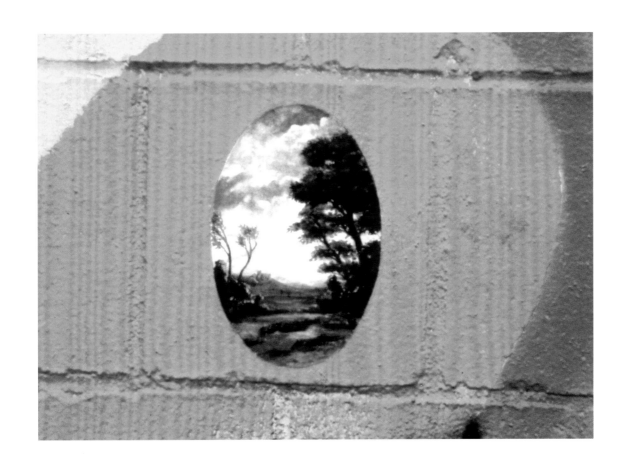

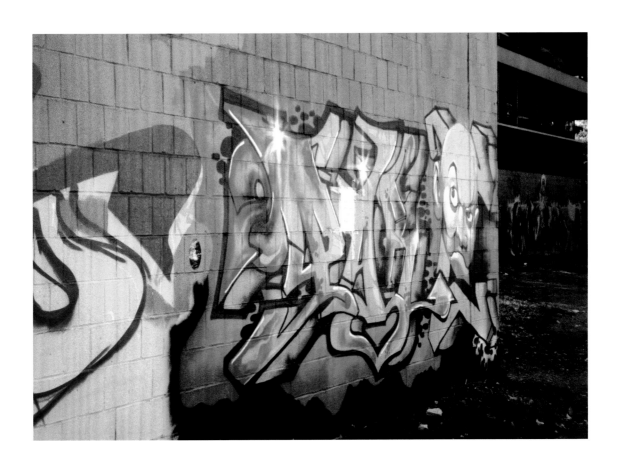

Northwest corner of Cortland Alley and White Street, in back of 380 Broadway, SoHo, Manhattan

November 2000

If you've ever seen a movie about New York City where the hero walks down a scary alley, this is probably the alley they used. It's always being filmed.

Because the alley was quite close to my studio at the Clocktower, I spent a long time on this painting. Somehow, though, it never quite worked. It's based on a painting by Carl Rottman, but I changed it a great deal and painted all these dubious little trees into it. Part of the problem may have been that it started getting very cold, and I found it difficult to paint while wearing gloves. Later, I started using those chemical handwarmers, which helped a lot.

This was a popular streetcorner. A group of homeless men hung out opposite; there was also a steady stream of teenage boys with gold teeth — the kind where the spaces between the teeth are filled, not the teeth themselves.

On the second day, a car full of cops drove down the alley very, very slowly. They rolled down their window, and I turned around and smiled as broadly as I could and waved enthusiastically, and then they rolled up their window and drove on. All the boys with the gold teeth had suddenly disappeared.

On the third day, a man came by because his truck had broken down and he was waiting for it to be towed. He asked me to do a painting on his truck, but I explained that I wasn't doing commissions. He then said that if I didn't paint his truck, he'd come back and blowtorch my painting off the wall. So I told him that I could tell that he was far too nice a person to do any such thing. He looked surprised and then asked me if I knew what he did for a living. It turned out that his job was to evict people who were behind on their rent. I said that had to be a tough job, and he said, "Yeah, I've got bad karma. Nothing ever goes right for me." It took a long time for the tow truck to arrive, and the man stayed around for several hours, during which he kept grabbing passersby and pulling them into the alley to see me and my painting. Since he was quite a frightening man, most of the passersby were rather alarmed and kept trying to escape. They looked relieved when they realized that they were only the victims of forcible art appreciation. The painting was still there the last time I looked.

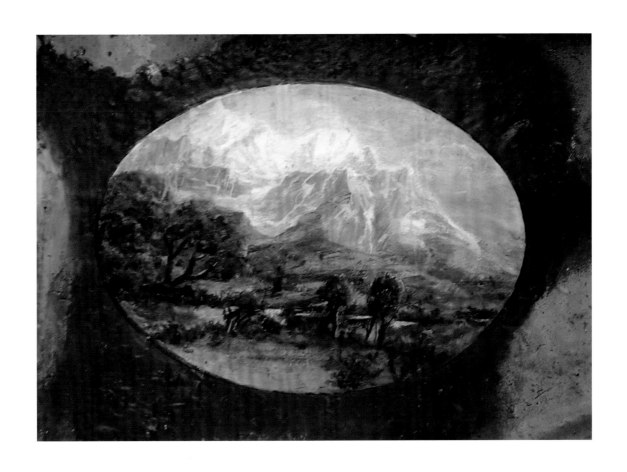

Staircase at 521 West 26th Street, Chelsea, Manhattan

November 2000

My gallery at the time, DeChiara/Stewart, was a bit concerned that I was spending so much time making paintings outside that couldn't be sold, so they asked me to do a painting near them so that they could at least show people what I was doing. I picked this staircase because it had graffiti for Al Gore, which I thought was funny.

By the time the super of the building noticed me, I had finished the white underpainting and had started painting a landscape based on a painting by Thomas Fearnley. Fortunately, he really liked it. I think he was bored and was happy to have someone to hang out with. He was concerned that I was painting outside. "It should be in a gallery. That way, you could sell it. It's too good to be destroyed." He pointed out that there were lots of galleries on the street and offered to introduce me to any art dealers who walked by. So every time someone walked by who he knew was a dealer, he would grab them and pull them over to me. None of them made eye contact with either of us or said anything. Even the ones that I knew didn't seem to recognize me, but I was wearing a lot of clothes because it was so cold.

A couple months later, I noticed that the super had painted over the Gore graffiti but had kept the painting. Then someone drew a silver circle around the painting and wrote a little prose poem about how much they would rather be in the country than in the city. Then the super painted over that, too. I later found out that both the Gore graffiti and the poem were written by an artist who lived in the building. I met him because, like myself, he was living illegally in a commercial building, and we were lobbying together in Albany to get the New York Loft Law changed so that it would protect people like us. Unfortunately, because Albany is so dysfunctional and because we didn't have any money, it was all a waste of time. I did get to meet all my local politicians, though.

I liked this painting a lot, so I made a postcard of the view of it from a distance. I recently went to visit this painting with Patrice Loubier, a Canadian writer who'd written about the project for *Parachute* but had never seen any of the paintings. Unfortunately, when they renovated the building, they removed the staircase, so the painting was gone.

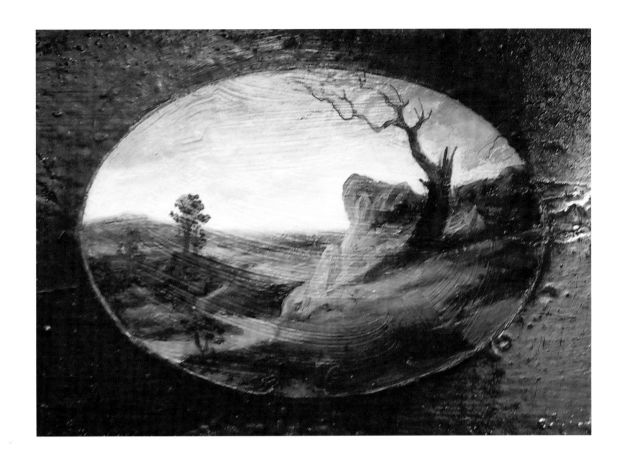

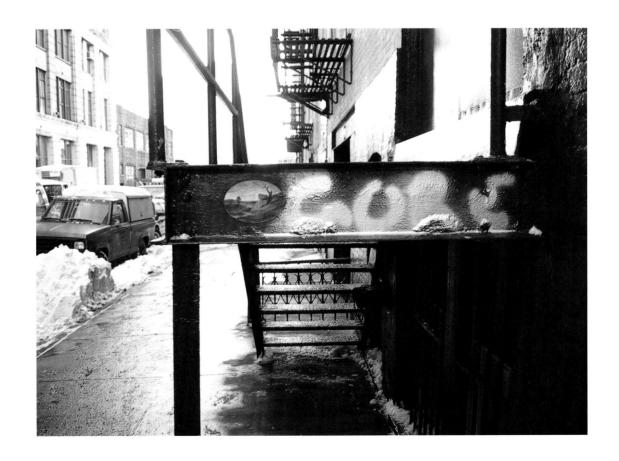

Southeast corner of West 14th Street and Tenth Avenue, Chelsea, Manhattan

November 2000

This painting was on the wall of a meatpacking plant. The wall already had a lot of graffiti. The meatpackers came by right away to tell me to leave, but then they decided that they liked the project and let me stay. The painting was based on a painting by Ludwig Richter of a pond in Poland. The workers kept coming back to see how it was going so it was hard to concentrate.

Halfway through the second day, I was suddenly slammed against the wall. Someone grabbed my arms and started banging me headfirst against the concrete. I thought I was being mugged. I was surprised to be mugged at two in the afternoon, but mainly I was terrified. Then I got turned around and saw that it was the police. There was a moment of silence before one of the two cops said, "We thought you were homeless." I said the only thing that occurred to me, which was "I'm not homeless." They looked at me for a bit, and then one of them asked, "You got permission to paint that?" I was so flustered that I said, "Well, not exactly, but it seems to be OK with the meatpackers." So one of the cops went off to the plant to see if I had permission and the other one stayed to make sure that I didn't run away. He told me that they'd been told to clean up the Meatpacking District. I tried to explain what I was doing, but he didn't seem very interested. He just kept yelling that the mayor, Rudy Giuliani, hated graffiti and that they were going to arrest me if I was painting without permission. I offered to paint over my painting so that the wall would look like it had before I came — covered with graffiti but without any landscape. This seemed only to enrage him further: "You don't touch that wall, ever, you understand?" Finally, his partner came back and pointed out that there was no way I could have permission, since the owner of the building was apparently dead. After shouting a bit more and telling me that they would arrest me if they ever saw me again, they let me go. Sometimes it really is a good thing to be a white woman in her thirties.

I didn't dare go back, so this painting never got finished. I'm not very brave. I didn't file a complaint, because I didn't want to bring myself to the attention of the police when I still had so many more paintings to do. The wall is all clean and repainted now and fits in well with the Meatpacking District's swank new look.

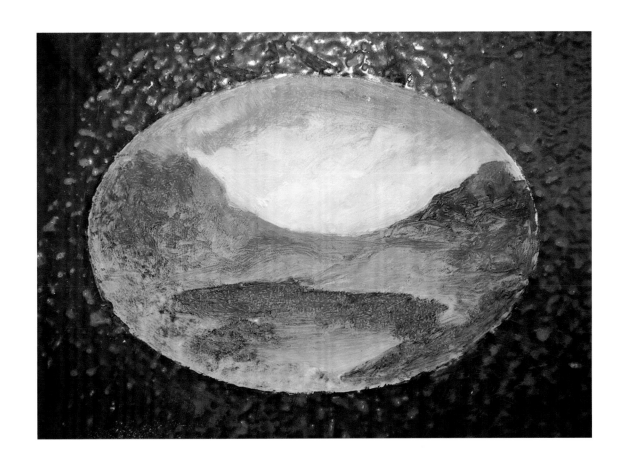

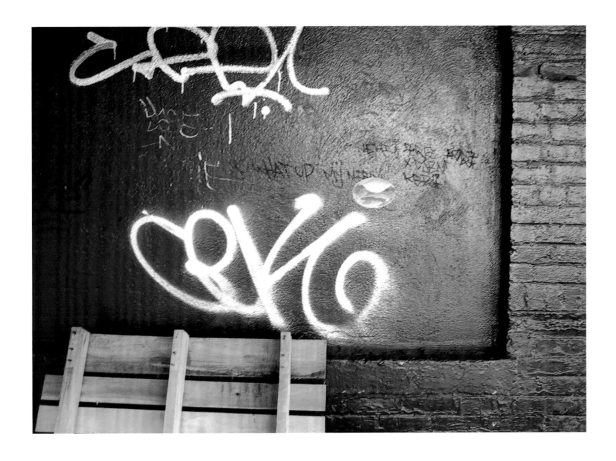

Traffic-control box on the corner of West 96th Street and West End Avenue,
Upper West Side, Manhattan

November 2000

For some reason, traffic-control boxes are always covered with graffiti scribbles, so I thought no one would object to my adding a painting — especially one based on Carl Rottman's very pretty *Taormina with Mt. Etna*.

This was a busy corner, and lots of people walked past me during the two days I spent painting, but only one man asked me what I was doing. He seemed confused by my answer.

Someone wrote to Daniel Schneider, who writes the FYI column in the City section of *The New York Times*, to ask why there was a landscape on the traffic-control box. He found me because at that point I had shown photographs of some of the paintings at GAle GAtes et al. I liked Daniel's explanation of the project, but the best thing was that the other question that he answered in the column was: "What was the biggest explosion ever in New York City?" Afterwards other people started to write about the paintings, claiming that they had seen them on the street, which seemed unlikely. I still wonder who originally wrote to Daniel.

When I came back to photograph the painting the next day, there had been a big snowstorm, which had abraded the paint. I was sad because I thought it was one of the better paintings I'd done at that point. Of course, once they repainted the traffic box, it was gone anyway.

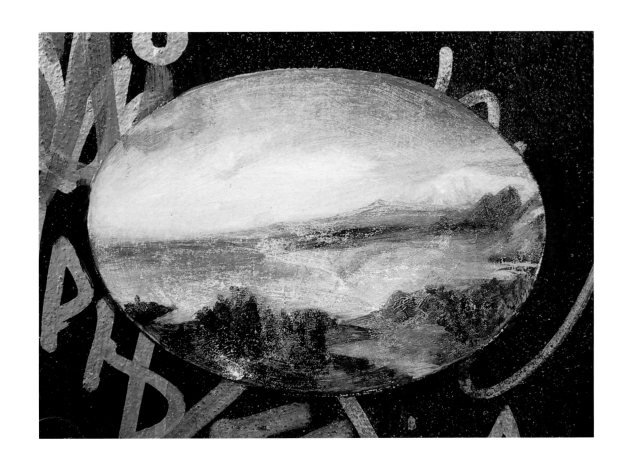

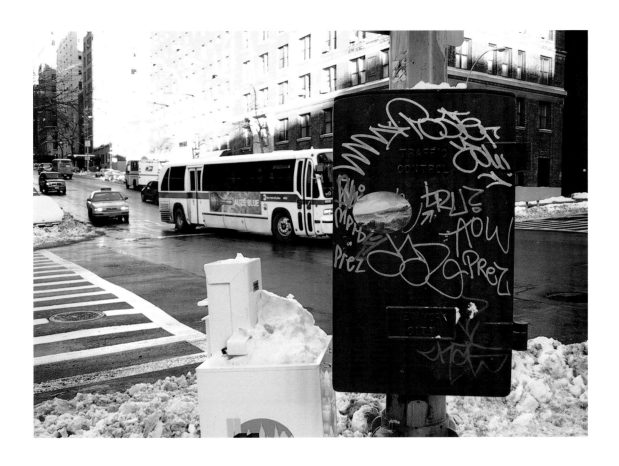

Entrance on the south side of 150 Franklin Street, Greenpoint, Brooklyn

November 2000

I did this painting here because my friend Becky Smith had opened her gallery, Bellwether, next door, and I wanted to surprise her. It was a lonely place to paint, which made me think that it might be a difficult place to have a gallery. No one came by for the two days that I spent painting. The gallery moved to another place in Williamsburg after that, and now it's in Chelsea with all the other galleries.

Later, I stopped by and noticed that someone had drawn a little whale in the lake in the painting. I stole the lake from a painting of Snowdon by Richard Wilson. It was still there the last time I walked by.

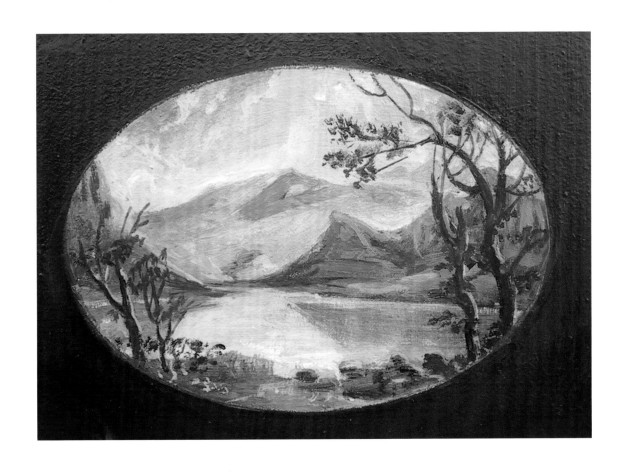

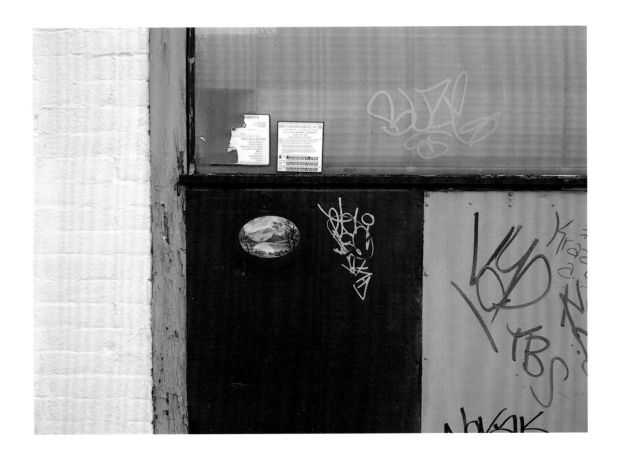

For some reason, this building in SoHo has avoided gentrification. It's completely covered with graffiti and full of garment workers. It's a bit like going back in time. The rest of SoHo is very fancy. It used to be a dying industrial area; then the artists moved in. With them came the galleries and then the shops. Now it's pretty much just a big, upscale shopping mall. The New York Loft Law, which protects people who moved into commercial buildings before 1981, started because of SoHo.

When I started painting, some of the garment workers came by to ask me what I was doing. They warned me that their boss really hated graffiti, and described him so that I could hide if I saw him. They also said they'd try to warn me if he was coming out.

A teenager stopped by to look at the painting. His family was from Russia, and he lived with his mother in Staten Island. He told me that he was a graffiti artist, too. He asked me if I'd ever been arrested. I had to confess that I hadn't. He had, and he was very proud of it. He asked me how old I was when I started painting, and I said that I'd started painting in oils when I was eighteen. He told me that he was eighteen and had just made his first painting on a canvas. He asked me if I liked Picasso and said, "He was the man. He lived the life." I had to agree.

When I went back the next day to photograph the painting, it was already covered with new graffiti, which was a shame, as it was quite a nice copy of Caspar David Friedrich's painting of an oak tree. Only slivers of the painting were visible. Now even that graffiti has been covered by other graffiti, and my painting is completely gone.

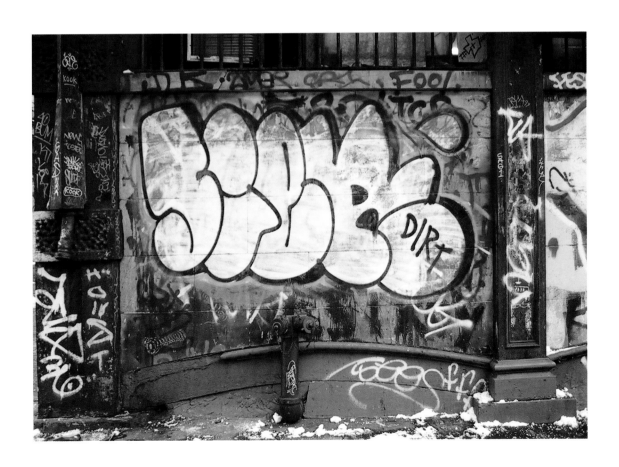

Door of 111A North 10th Street, Williamsburg, Brooklyn

December 2000

This is the door to the studios next to mine. Like everything on our street, it's always covered with graffiti. No sooner is the door painted than it's covered again. I thought that, for once, I'd be part of the problem rather than always trying to be part of the solution. It was very relaxing to paint so close to home. I was still feeling a bit nervous after my encounter with the police.

Nothing much happened while I was painting this one. It was based on a little oil sketch of Etna by Gustaf Söderberg. It didn't last very long before it got covered by new graffiti. We painted the door silver recently, but it's a losing battle.

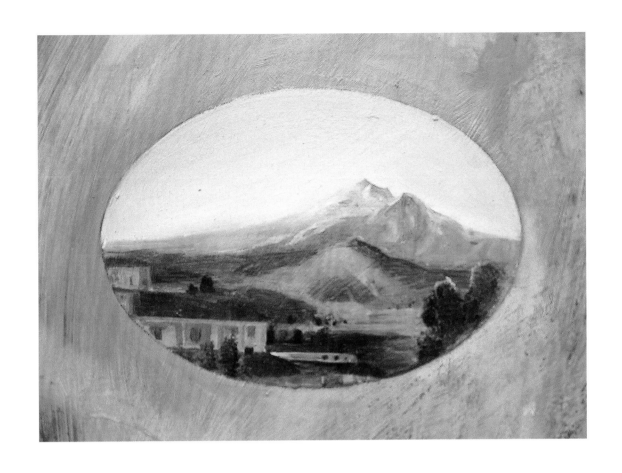

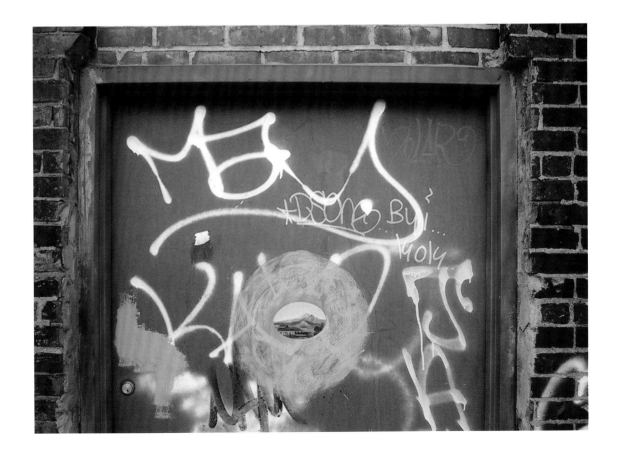

Car next to 111 North 10th Street, Williamsburg, Brooklyn

December 2000

I have to admit that I thought this car was abandoned. It was next to my studio and hadn't moved for months. It was covered with parking tickets. I just couldn't resist. The painting was based on a landscape painting of Zealand by Johan Lundbye.

Of course, I got caught by the car's owner, who turned out to be a movie director called Peter Mattei who lives in my building. But he really liked the painting, so it was OK. Maybe I knew that it was his car, but I'm just not sure. He'd left the car behind while he was working on a movie. At that point, the "No Parking" signs on our street were missing, so we didn't have to move our cars. Now we have new "No Parking" signs and have to move our cars every day, even though we don't seem to get much in the way of street cleaning.

Later, I saw the car on the street with a sign that said, "Original painting by Ellen Harvey, as seen in *The New York Times*: $800 (car included)." I'm not sure who bought it and Peter doesn't remember. I gave Peter a photograph of his car as a souvenir. Recently, someone pulled down one of our new "No Parking" signs to the excitement of all the car owners in our building.

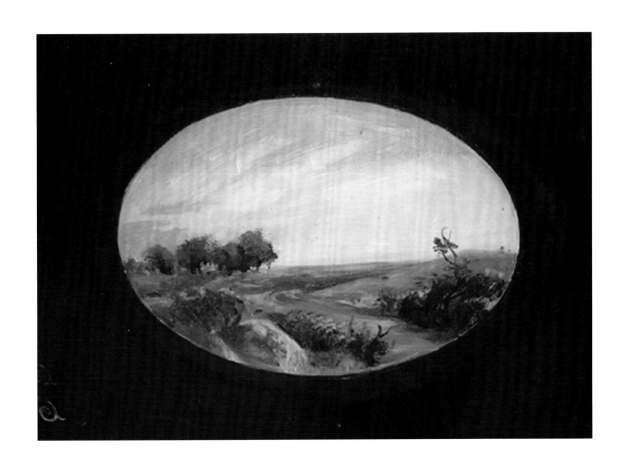

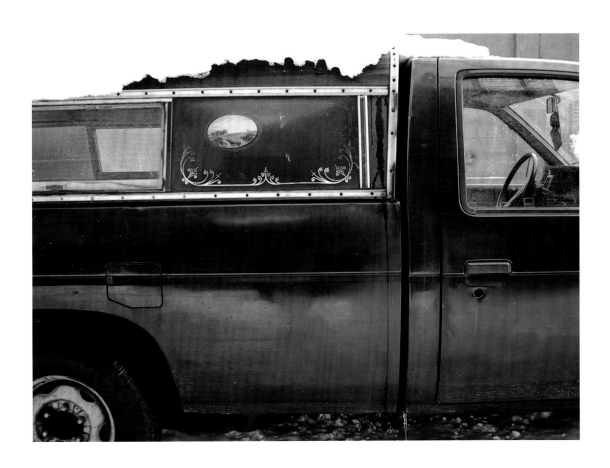

Back of 201 Water Street on Plymouth Street, DUMBO, Brooklyn

December 2000

I chose this location because of the "DUMBO = SoHo" graffiti, which I just couldn't resist. It wasn't really a very good site for painting otherwise, because the wall was so bumpy, even after I'd sandpapered and primed it, so my version of Kàroly Markò the Elder's *Landscape with the Walk to Emmaus* was pretty rudimentary.

I painted this one quite quickly because it was so cold. I had chemical handwarmers, but my feet got really cold standing in the snow. Most of the people who came by just asked me things like, "Aren't you cold?" No one seemed interested in what I was doing. I think it was too cold to stop to talk.

Later, when I was working with the Live Work Coalition, trying to change the law to protect people who had moved into commercially zoned buildings, I met an artist called Anne MacDonald, who said that she'd watched me making this painting. She lived around the corner. She's not in DUMBO anymore, because her landlord tormented all of his tenants to get them out because he wanted to get the building rezoned and rent it for more. He also called the Buildings Department and had his tenants in another of his buildings on Water Street thrown out into the snow on two hours' notice just before Christmas. At the time, the Buildings Department claimed that the Fire Department had said that there was an "imminent threat" to the tenants despite the fact that they'd been living there with the Fire Department's knowledge for about fifteen years. Those people never got back into their building because the landlord never made the improvements that the Buildings Department subsequently claimed were necessary. As far as I know, the landlord ended up not getting a zoning variance on his buildings and then they all burned down mysteriously. So DUMBO is like SoHo after all, but without a Loft Law. Both the painting and the graffiti were still there when I last looked, but that was several months ago. I'm not in DUMBO so often anymore, since most of my friends have been priced out.

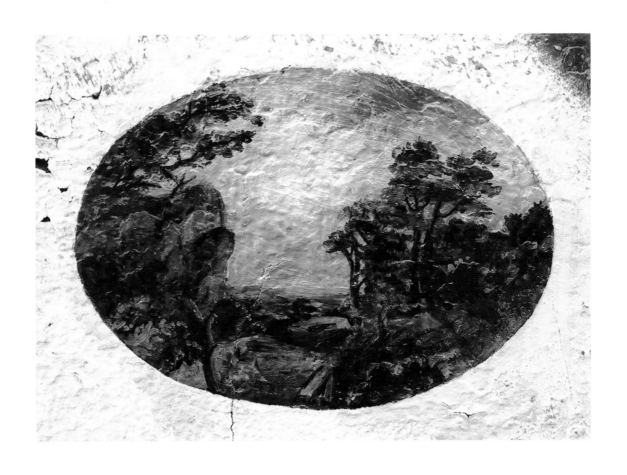

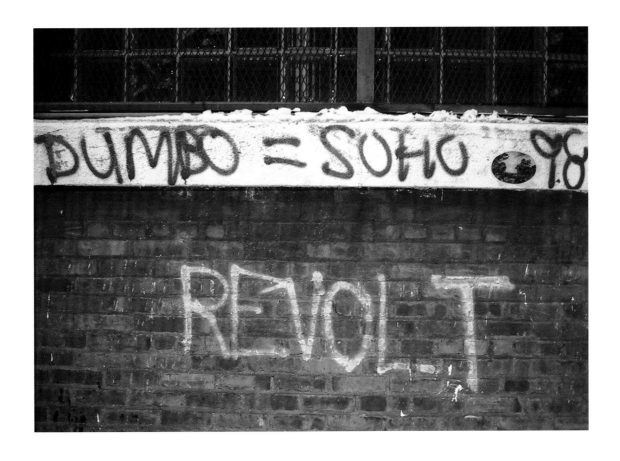

Warehouse door at Main Street and Plymouth Street, DUMBO, Brooklyn

December 2000

This was another very calm place to paint. Because the weather was so bad, no one was out much. One older German woman stopped by. She was visiting her daughter for Christmas and said that she'd bring her daughter by later to see the painting, which was based on a lovely watercolor of Greta Bridge by John Sell Cotman.

By this point, I was pretty tired of painting in the snow. It was hard being cold all the time, no matter how many clothes I wore or how many chemical handwarmers I secreted in them. Of course, it was my own fault that I was painting in the winter. I wanted to finish a respectable number of the paintings so that the photographs could be in a show at GAle GAtes et al. on January 11. The show was curated by Lauren Ross and was called "Serial Number." It was about artists who work in series, so showing just one or two paintings wasn't really an option. When I had told Lauren that I'd show the project, I had thought that I would be further along. But my plans of painting in the summer hadn't worked out, as I'd had to go to Frankfurt to work to make money instead. For some reason, I mounted the fifteen photographs for the show on aluminum, which was really expensive and looked pretentious. They turned out to be useful as donations to benefit shows, so printing them wasn't a complete loss. This painting got eaten up by the rust on the wall fairly quickly.

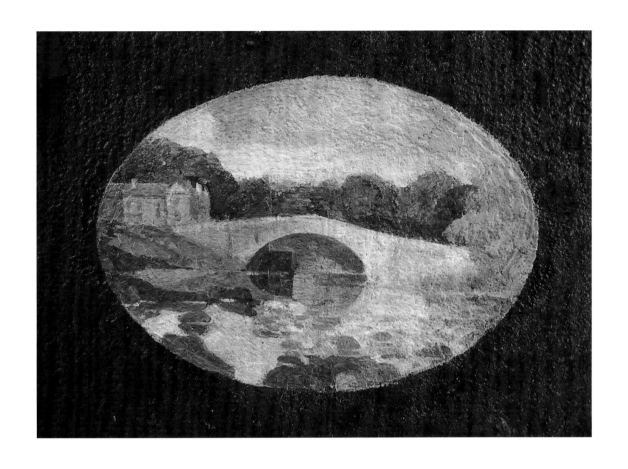

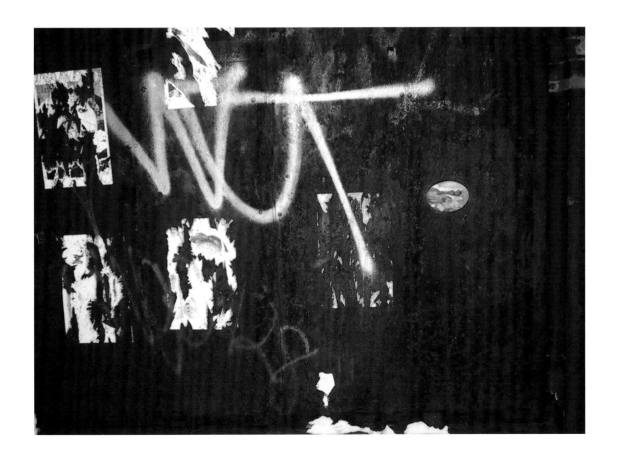

Door on abandoned firehouse on 132nd Street between Lenox Avenue and Fifth Avenue, Harlem, Manhattan

December 2000

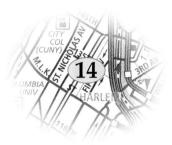

My friend Franklin Sirmans suggested that I do a painting near his home in Harlem, and I picked this abandoned firehouse because it's such a lovely, grand old building and it looked as though it could use some help.

Once I started painting, children from the neighborhood came by and wanted to paint, too. I let them paint over the graffiti — they mainly painted little crosses and dots. You can see their efforts at the bottom of the photograph. It was very hard to get all the oil paint off them when they were done. I tried to keep them away from the more toxic colors, but without much success.

One older lady stopped by and said, "It's nice to see a young person use her talent for good." Another man asked me if I was going to cover the whole building. He was disappointed when I said that I wasn't. A lot of people were upset at the neglect of the building and were saddened to find out that my presence wasn't the beginning of a larger attempt at renovation.

I originally painted a ruined aqueduct from my imagination and took a photograph for the show at GAle GAtes et al. After I looked at it for a while, I decided that I really disliked the aqueduct and I went back and changed it to a more conventional landscape. It was still there when I last looked.

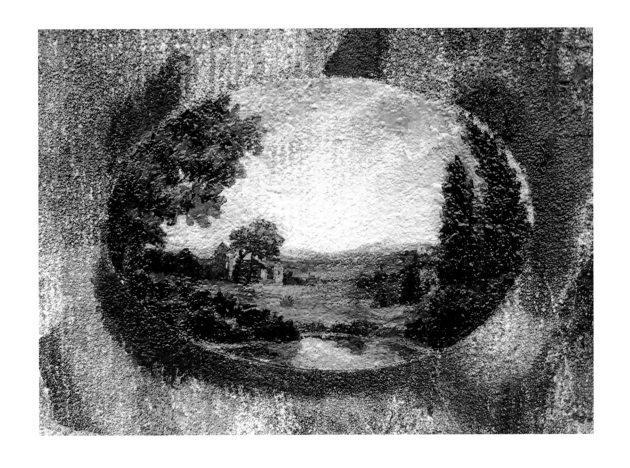

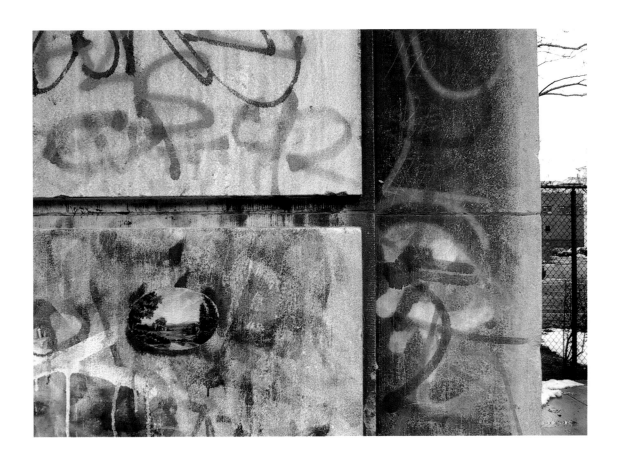

33

Inside courtyard opposite 45-31 Davies Street off Jackson Avenue, Long Island City, Queens

January 2001

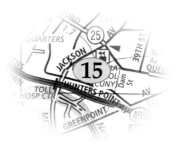

This was in the courtyard of the Fun Factory, a sort of graffiti museum. It has beautiful graffiti all over it that I'd always admired. I really wanted to add to the graffiti, but I wasn't sure how to do it. Since I'm not a graffiti artist, I thought it would be best to do it by stealth. So I painted the undercoat one evening when the Factory looked empty. Then I came back at daybreak on New Year's Day because I thought that any self-respecting graffiti artist would either still be out celebrating or fast asleep. Unfortunately, it had thawed slightly, so the space in front of my painting had turned into a lake of freezing slush. It was one of the more miserable New Year's Days of my life.

I picked this graffiti because I thought it was beautiful. I didn't paint over it because I liked it so much. I painted this painting so fast that it didn't turn out terribly well. My painting is embarrassingly less beautiful than the graffiti. I made up the painting, so its shortcomings are all my own fault.

I don't know who made this graffiti, because I was too shy to ask at the time. The Fun Factory doesn't exist anymore, and this graffiti is gone, along with my painting. An organization called The Five Pointz took its place. I asked them if they could tell me who made this graffiti, but they couldn't, nor could anyone else I asked.

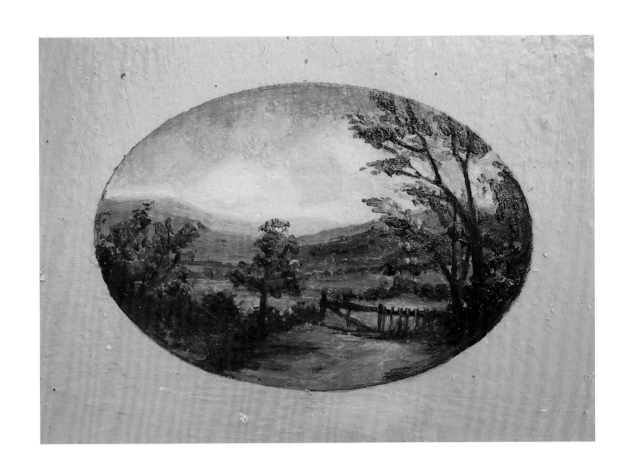

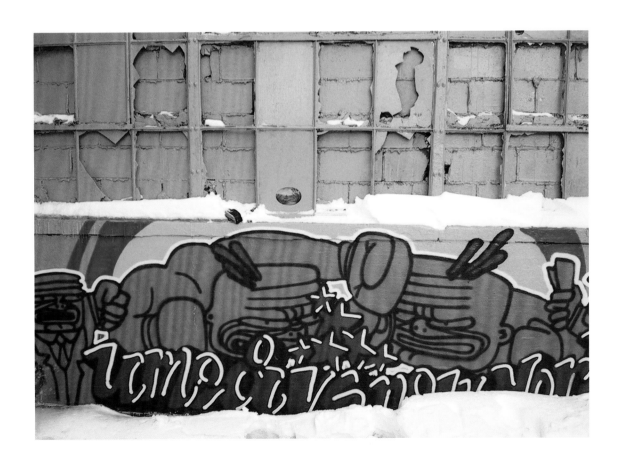

175 Ludlow Street, between Houston Street and Stanton Street, Lower East Side, Manhattan

January 2001

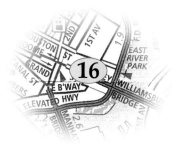

I painted this next to the door of a building that was undergoing renovation, so everyone thought the piece was part of the renovation. No one bothered me at all, except for the construction workers, who were very flirtatious.

I made this painting up and put in a seal because it was near my friend Jan Baracz's house and he likes seals. It didn't last very long, because the renovators painted over it.

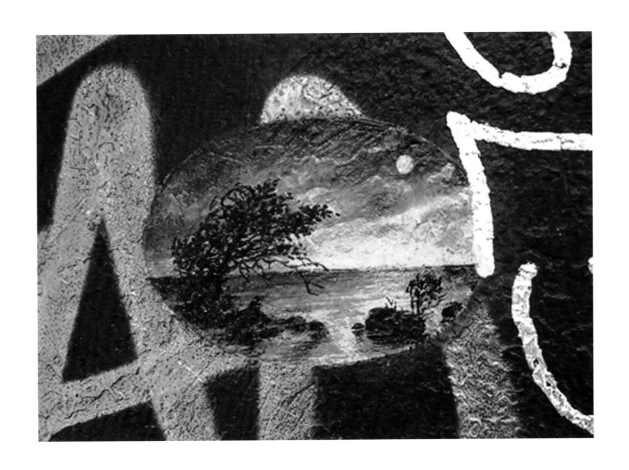

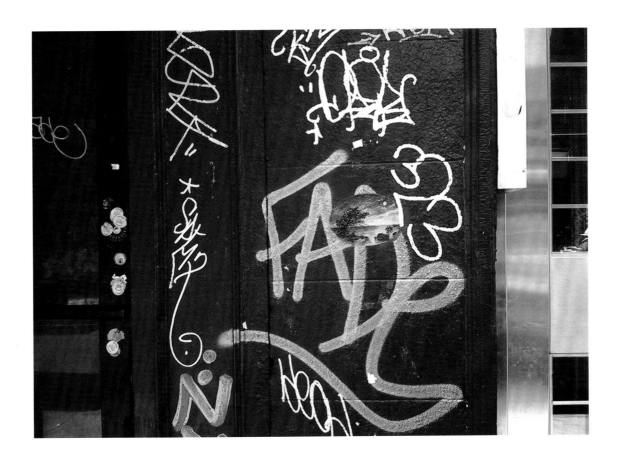

Spring Street side of 190 Bowery, SoHo, Manhattan

January 2001

This building has a remarkable amount of graffiti on it. One of the caretakers came out to see me as soon as I started, but decided to let me stay. He warned me to look out for the owner who, he said, was enraged by graffiti. Since he didn't describe the owner, his warning wasn't very helpful. A lot of police cars kept circling the area, which made for a fairly tense experience. I kept on having to walk away and then come back.

An African-American couple from Philadelphia stopped by, and the man told me that he used to live in New York. He told the woman, "See, this is why I love New York — this kind of thing is always happening here." He told her all about other illegal public art projects, like the little American flags that someone stuck in the dog shits on the street during the last Gulf War and the guy who glued old plates to the bottoms of the lampposts. They made a passerby take a photograph of themselves with me.

The painting is based on Thomas Fearnley's *Old Birch Tree at the Sognefjord*. It lasted for almost two years before it got tagged.

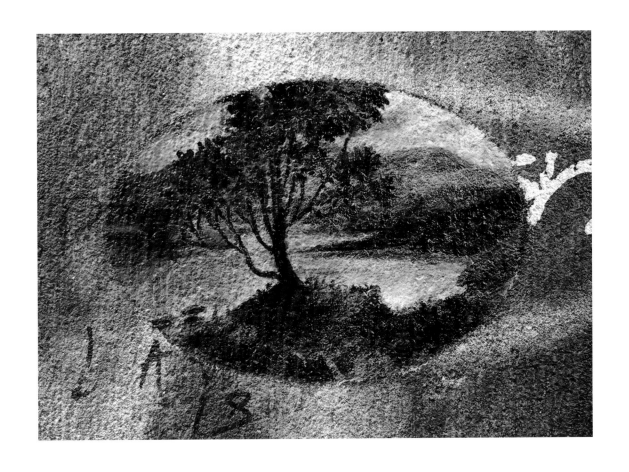

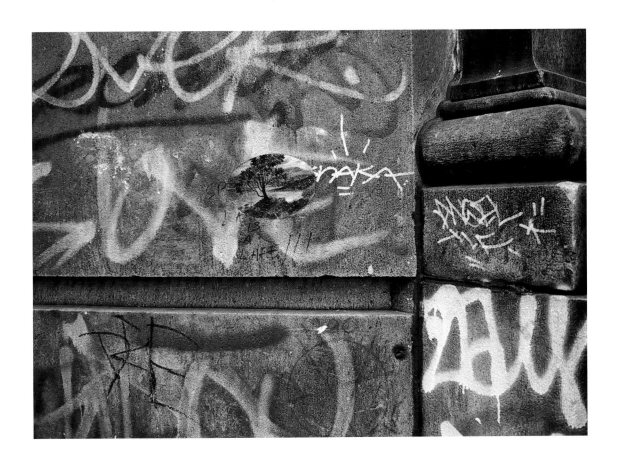

Abandoned house on the north side of 231 Front Street, south of Peck Slip near the Fulton Fish Market, Manhattan

January 2001

This building had some sort of gutter disaster, which meant that I got sprayed with freezing water for most of the time that I painted there. No one stopped and spoke to me, except for one man in a suit who asked, redundantly, "Getting wet?"

The painting was based on *View at Civita Castellana* by Gustaf Palm, and I liked the way my version turned out, so I used it for the cover of the map that I had printed when the project was finished. After all, you can't have a public art project without a map. Artists Space was very kind and gave me $500 toward the cost of printing the map, which was designed by Jan Baracz. My art dealer, Richard Stewart, also gave me $1,000. We printed three thousand copies of the map and gave them away for free. Paintings that still existed and were accessible were marked by orange ovals on the map. Gray ovals marked the sites of paintings that had been destroyed, damaged, or moved. I also marked sites in gray that I thought might be dangerous to visitors, which was just as well, as I later met some school teachers who had used the maps to take their students on a tour of the city.

I later gave a talk at the Whitney Museum with Karen Jones as part of the "Initial Public Offerings" lecture series that my friend Raina Lampkins-Fielder organized. Afterwards, my art dealer Laurie De Chiara and Moukhtar Kocache went out for a drink to a cigar bar in the neighborhood of the museum. They ran into Mayor Giuliani and they gave him one of the maps. He looked at it and said, "This is the kind of art the city needs," and signed it and gave it back. I'm not sure if he realized that it was illegal. I still have the map. It's a bit of a dubious endorsement, but it goes to show that you can get away with a lot if your aesthetics are conservative enough. Of course, this was before Giuliani became the hero of 9/11 and when he was still hated by the art world for his mad response to Chris Ofili's painting of the Madonna with the elephant turds.

The last time I went by, my painting was still there. The Fish Market is moving to the Bronx in 2005.

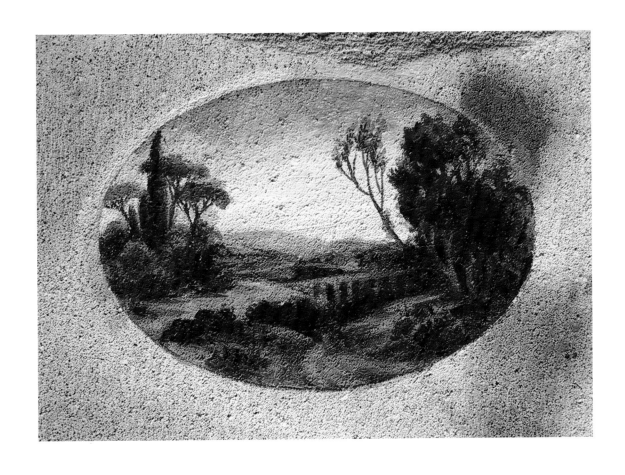

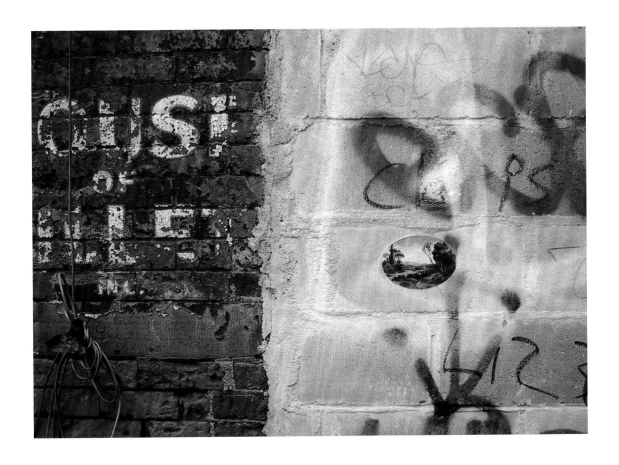

41

Brooklyn-Queens Expressway pillar at the corner of Meeker Street and Graham Avenue, Northside, Brooklyn

January 2001

No one bothered me while I did this painting. Cars slowed down, but then they sped up again. I wore my neon orange jacket so that people would think I was official. My sister Matthea lived nearby and I hoped that she would see the painting whenever she walked to see me. Unfortunately, it wasn't directly in her path, so that didn't happen.

I liked the color of the pillar. It's quite a romantic color for a pillar. You wouldn't expect an expressway pillar to be pink. The painting was based on Carl Fahlcrantz's *View over Haga*. As far as I know, it's still there.

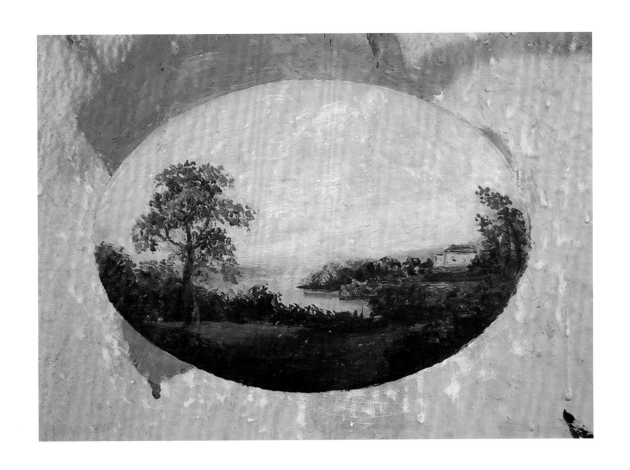

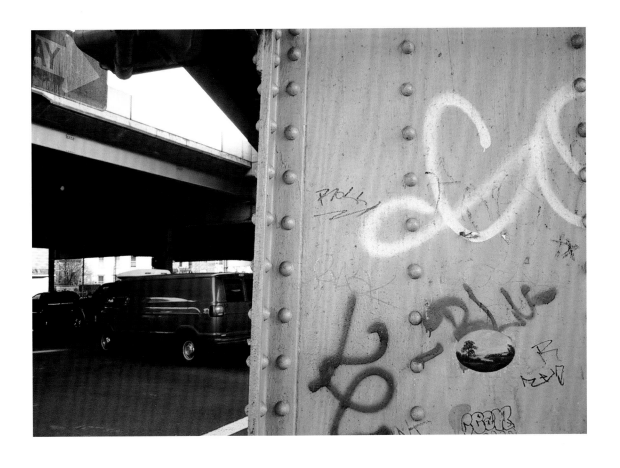

103 Franklin Street between Church Street and West Broadway, TriBeCa, Manhattan

January 2001

This was the second time that I made a painting based on Caspar David Friedrich's painting of an oak tree. The first version in SoHo got covered by graffiti the day after I finished it, which made me sad because I had liked it a lot. Unfortunately, I never liked this second version as much. Maybe because it had lost the charm of novelty. Or maybe the lost first version was just better.

I made this painting here because Karen Jones had asked me to be in a show about public art called "In/Site/Out" at Apex Art in March 2001. This building was right around the corner from Apex Art. Because Apex was worried about the illegal nature of my project, they made me sign a form stating that they in no way endorsed or promoted or were liable for anything that I did. By the time that the show opened, I had made forty paintings, and I decided to stop. The project was getting written about more and more, and I was worried that it would come to the attention of the authorities. So I never made it to my goal of doing one hundred paintings. At Apex, I showed snapshots of the paintings, which I glued to the wall. Apex was very concerned about the glue sticking to the walls, so I used a really weak kind of glue. As a result, the photographs kept on falling off the wall and having to be stuck back on again.

While I was painting here, a man came up to me and asked me to sign his portfolio. He thought that my signature might be valuable someday. His portfolio was made out of plastic, so my signature wouldn't stick. I ended up signing his subway map in oils instead. This building finally got renovated and the painting is gone now.

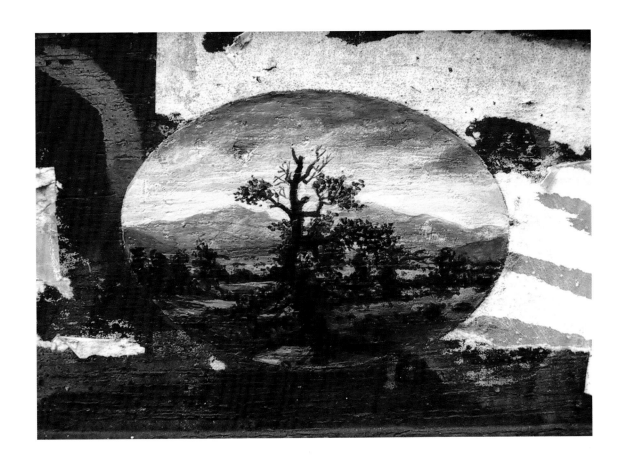

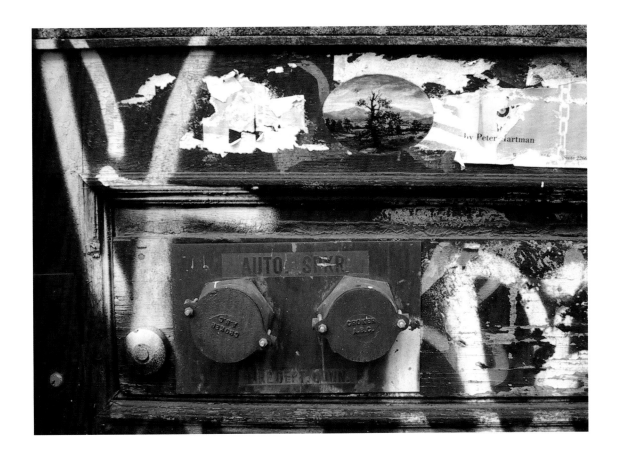

South 11th Street side of 475 Kent Avenue, South Williamsburg, Brooklyn

January 2000

I knew this building because the artists who originally built the space that I live in had moved here when I took over their lease. I also really liked the Pac-Man-like graffiti. I don't know who made it. This painting is one that I made up because I'd run out of books on landscape paintings at that point. Because the wall was so rough and crumbly, it was hard to paint detail, which is why all the foliage looks abnormally large.

I keep running into people who live in the building, and they tell me that the painting is still there. I didn't meet anyone while I was painting it, except for the people who worked at the bakery on the ground floor, and they were very shy.

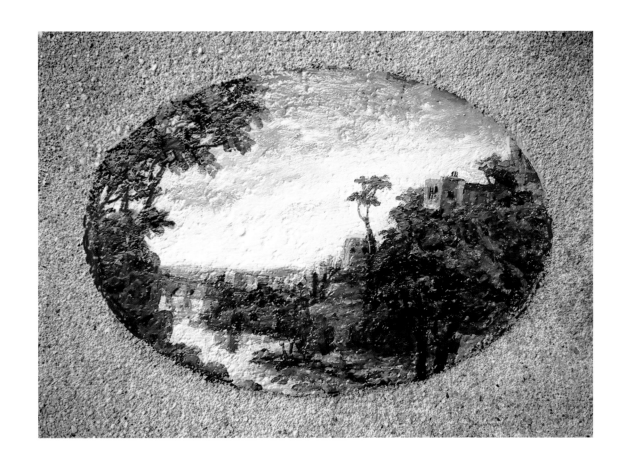

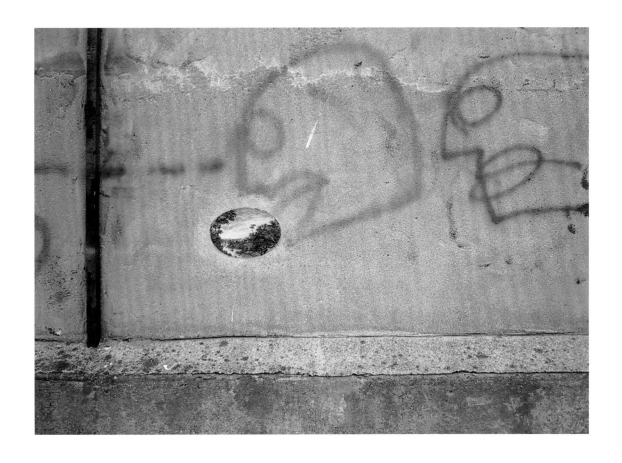

Wooden siding west of 529 East 13th Street between Avenue A and Avenue B, East Village, Manhattan

February 2001

There was some sort of renovation project going on here, so they had put up siding, which they painted blue. I'm not sure why siding is so often painted blue in New York City. Maybe blue is an especially cheap color.

On the second day, a group of teenage boys sitting on the stoop opposite the wall kept yelling "Police!" and "Stop, graffiti!" and then laughing like hyenas every time I turned around in panic.

When I was almost finished, a man came up to me and asked me if I'd do a similar piece in one of the local community gardens. I explained that I wasn't doing commissions, but because I really like community gardens, I agreed to do a separate piece for him later. Unfortunately, we never managed to meet up, so nothing came of it.

This is one of the images that I made into a postcard because I liked it so much. It's based on Gustaf Palm's *View from Narni*. The siding has been taken down now.

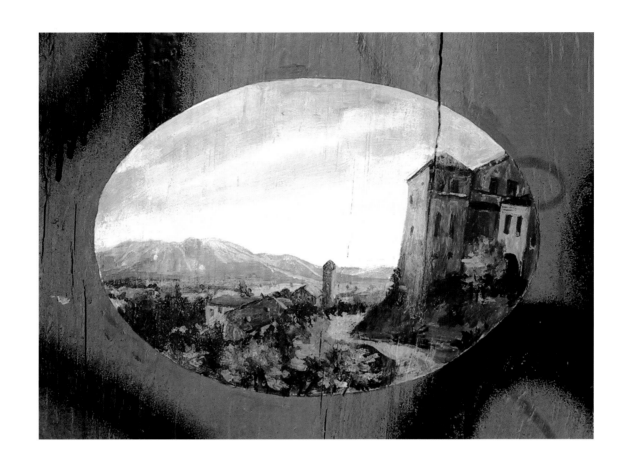

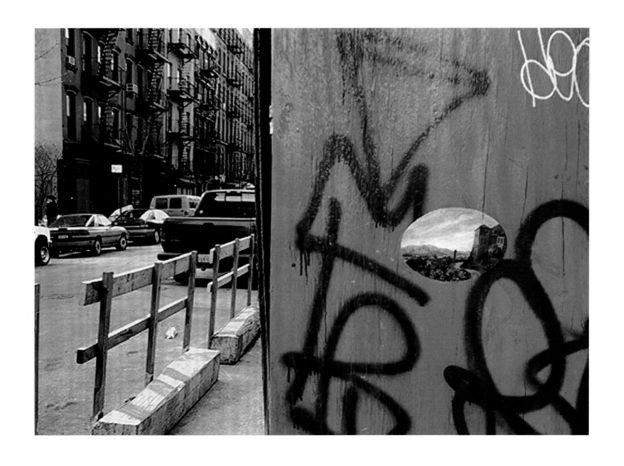

Cover of trash receptacle next to 14 Collister Street between Hubert Street and
Laight Street, TriBeCa, Manhattan

February 2001

This is another archetypal alley, but a rather nice one. It was tricky to paint on the wooden cover of the receptacle, because it was so dirty and the dirt kept getting into the paint. The painting is based on Arnold Böcklin's *Die Toteninsel* ("The Island of Death"), which is one of the great melodramatic paintings of all time. Böcklin must have liked it, too, as he made several versions of it. I saw it for the first time when I lived in Berlin in 1990 and was very taken with it.

Absolutely nothing happened here. I just spent two days painting in delicious solitude. I would definitely recommend this alley for illegal activities of all kinds. And, when I last looked, my painting was still there.

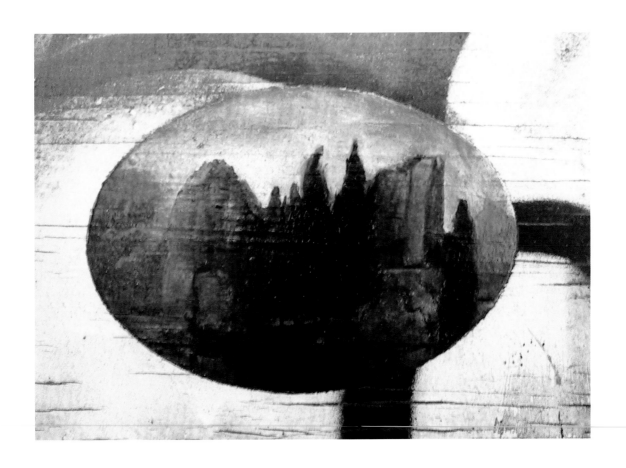

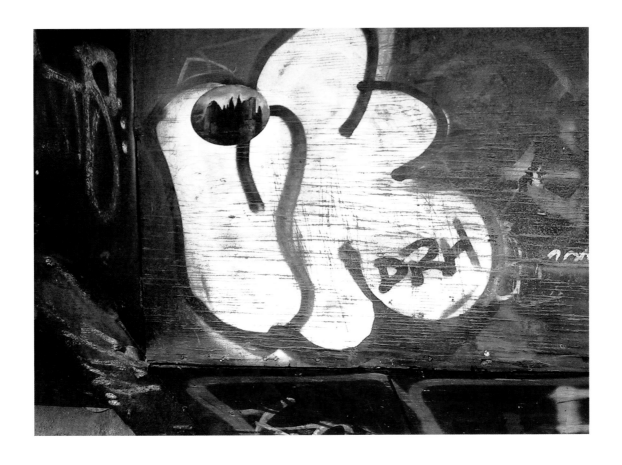

Door next to 525 Greenwich Street between Spring Street and Van Dam Street, SoHo, Manhattan

February 2001

I really liked this door and its graffiti. It was very bright and cheerful. Lots of people stopped to see what I was doing. Most of them laughed. One elderly couple told me to be careful.

A construction crew was working behind me while I painted. On the second day, one of the men came up to me to see what I was doing. When I looked behind him, I could see all the other construction workers giggling, a bit like teenage girls who have dared one of their friends to talk to a boy. He asked me what I was doing and when I showed him, he asked if I would paint his name into the painting. I explained that I was doing landscapes rather than names. He said that he was called the African Hammer and suggested that I paint a small hammer into the landscape. I asked him why he was called the African Hammer, and he said that it was because he was from Zimbabwe. He didn't explain about the hammer part and I didn't paint a hammer into the painting. He was very polite. For the rest of the day, he kept on waving at me each time I turned around, and then all the other workers would laugh.

Perhaps I was intimidated by the niceness of the graffiti, but for some reason this painting wasn't so successful, I thought. Both the color and the composition didn't quite work. It's very loosely based on some nineteenth-century paintings of the Bay of Naples, but I can't remember which. I think it's still there.

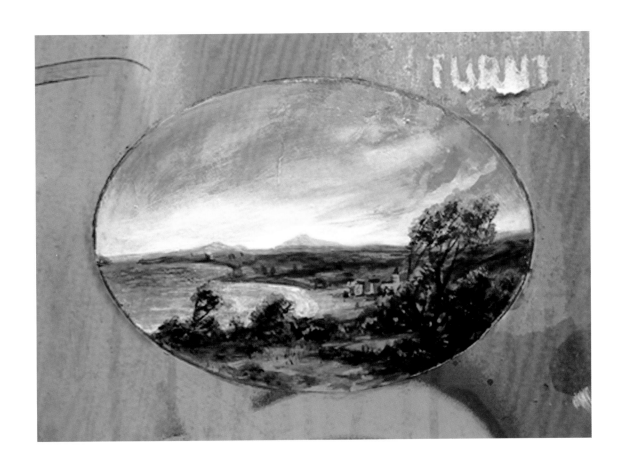

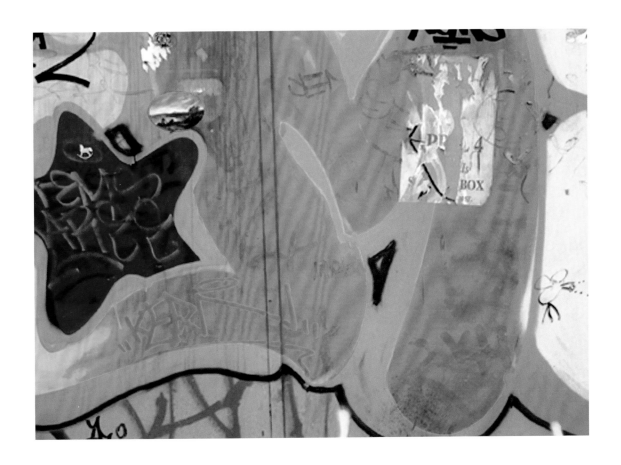

55

This was a nice, derelict part of the street. Several men were sitting on the sidewalk, and they kept coming by to look at the painting and then to piss against the wall. Fortunately, the cold weather meant that it didn't smell too bad.

Because there had been a "Mory Story" human interest piece about my New York Beautification Project on Channel One, after the first piece appeared in *The New York Times*, one man came up to me and said, "You're the lady from the television," and asked me to sign a paper bag for his daughter. I was embarrassed by seeing myself on television. I thought I looked ridiculous. Fortunately, it was only for about four minutes. I much preferred being on the radio. I hate being photographed or filmed.

I felt quite nervous painting here, because it was so exposed. A surprising number of police cars kept passing by. At one point, a police car stopped and the officer got out and asked me if I had permission. I lied and said yes. Luckily, it was Sunday, and there was no way of checking because the store next to the wall was closed. He told me that he hoped I was telling the truth and that, if I wasn't, he hadn't seen me, which was very kind of him. I decided then to finish the painting that day. Later, I realized that there was a police station just around the block.

The painting is based on Johan Thomas Lundbye's *Goose Tower*. I'm not really sure what the tower has to do with geese, though. The painting was still there when I looked a couple months ago.

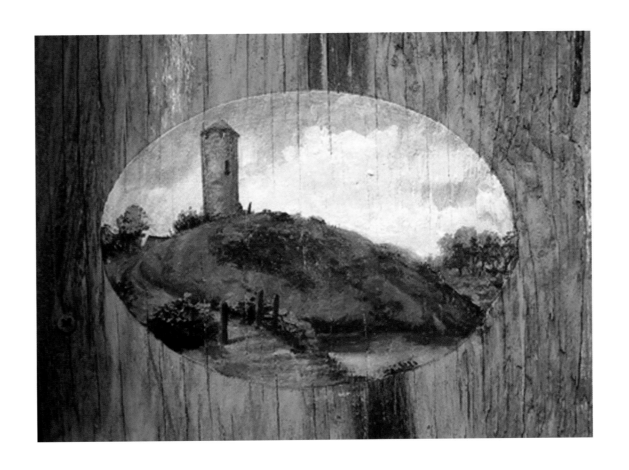

Telephone booth on the northwest corner of Berry Street and Broadway, Williamsburg, Brooklyn

February 2001

This is next to Diner, which is one of my favorite restaurants. I thought it would be nice to have a painting to visit when I went there. The painting is based on Paul Sandby's watercolor, *Roadway Through Windsor Forest*. I liked the idea of painting over the little holes in the telephone booth that make up the logo for the booth.

Unfortunately, people use the booth to put up signs for bands and apartments and so on. As a result, my painting disappeared quite quickly. My friend Brook said that for a while she kept ripping off the posters, but she eventually gave up. It's completely buried now.

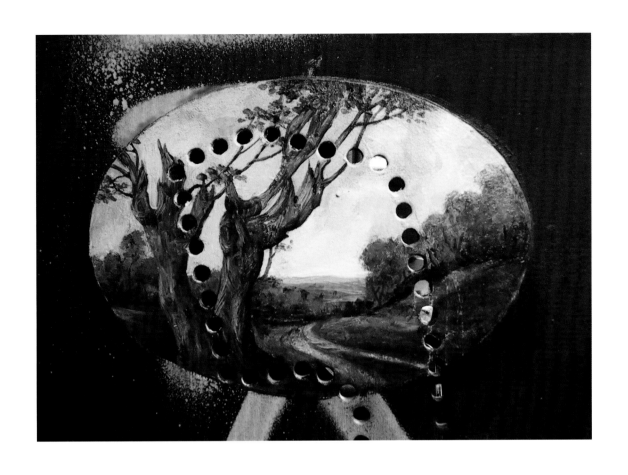

Power box on fence at the western end of West 71st Street, Upper West Side, Manhattan

February 2001

This is an unusual street in Manhattan, because it's a dead end. I thought that, as a result, it wouldn't have too much traffic, but it turned out to be very busy. I think the people who live on this street must need a lot of work done on their apartments, because there were a lot of handymen coming and going. The men teased me about calling the police, but none of them did.

As I had created a new art attraction in the city, I decided that my paintings should be available as postcards, just like real tourist attractions. I tried to get the postcard companies in the city to make cards for me for free, without much success. In the end, Postcard.com took pity on me and very kindly distributed five thousand free cards of the distance view of this painting through their cardholders in restaurants in May 2001. They made me pay for the production of the cards, but they gave me a good deal on the price because it was an art project.

I recently met someone who lived on this street, and I asked him if he had noticed any increase in traffic in May, but he said that he hadn't. He had noticed the painting, though. So my attempt to turn the electrical box into a tourist attraction was obviously unsuccessful. The painting has been painted over now.

Because I liked the postcard idea so much, I eventually showed the project in specially made plexiglass postcard holders. Unfortunately, after making the cases, I could only afford to make postcards of six of the images, so I glued photographs to the back of the postcard holders for the rest to make it look as though there were cards of the entire project. I showed the postcards along with the map at the P.S.1 Contemporary Art Center in Long Island City during their open day for the Studio Program and at the Studio Program's final show in the Clocktower. Because of the limited number of cards, people kept complaining that most of the cards had run out and asking me to refill the holders. I spent a lot of time explaining that I hadn't been able to afford to print all of the images and that I'd faked the other cards.

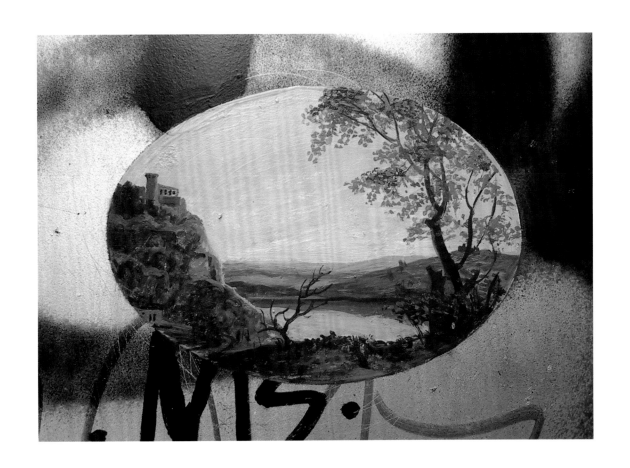

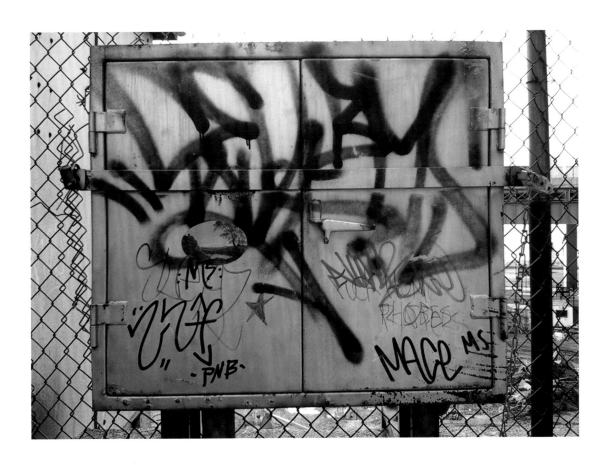

Southeast corner of Meserole Street and Moultie Street, Greenpoint, Brooklyn

February 2001

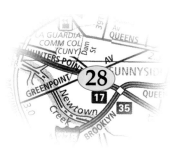

This is the industrial park section of Greenpoint. It's busy during the week, but it was deserted on the weekends when I was painting.

I made up this painting. It was meant to look like a romantic pastoral scene, but somehow it ended up looking more like a primordial swamp. Part of the problem was that the wall was extremely rough. Even after I spent several days gessoing and sanding my oval, I still had trouble painting the detail. As a result, all my foliage ended up being inappropriately large and menacing.

I left my cell phone here and couldn't find it when I came back the next day. I tried calling it and a woman answered. When I asked her to give the phone back, she laughed and said, "Yeah, right!"

The painting was still there when I last drove by.

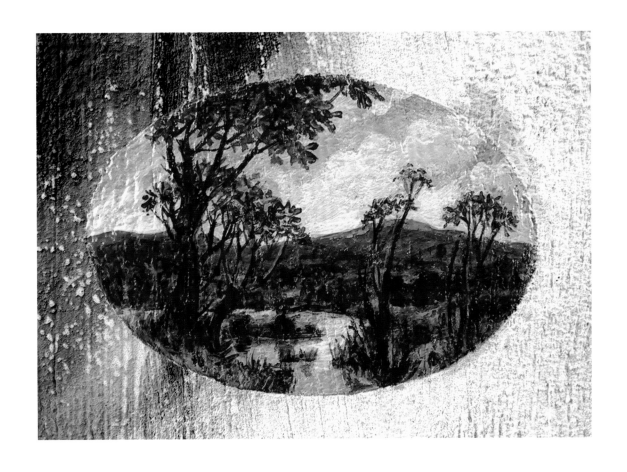

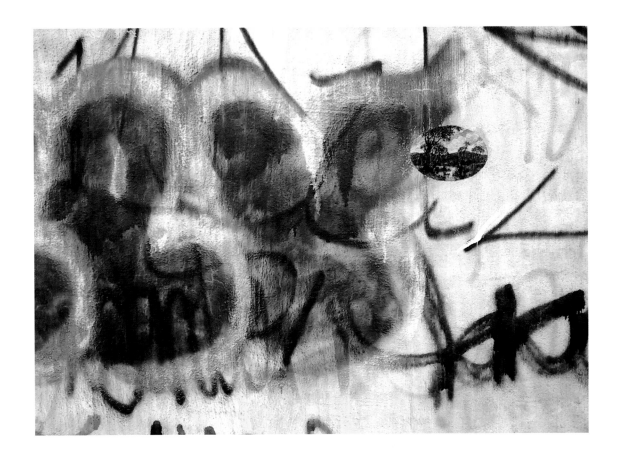

436 West 126th Street between Amsterdam Avenue and West 127th Street, Harlem, Manhattan

February 2001

I first went to this street because of The Project, which is a gallery that I like. The street is a bit desolate, with lots of abandoned buildings, despite being so close to the main thoroughfare of 125th Street. Maybe it was too desolate to support a gallery, because The Project is now on 57th Street with all the very established galleries.

While I was painting, a girl came by and asked me to paint her name into the painting, but I refused. She said that she understood, but that she'd always wanted to be in a painting. She thought the painting was beautiful.

Later, a man came by to see what I was doing. He was a musician and had just come back from playing in Germany. He asked me out to dinner, but I explained that I had a boyfriend. He said, "How do you know you wouldn't like me better?"

The painting is based on Richard Wilson's *View on Hounslow Heath*. The rust from the girder on which I painted has seeped through this painting, making it almost invisible.

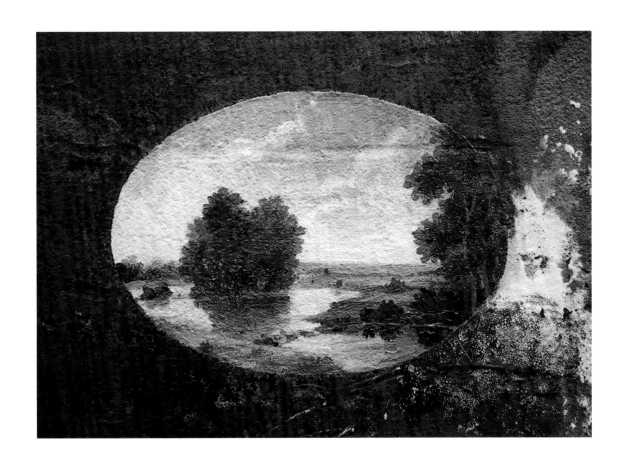

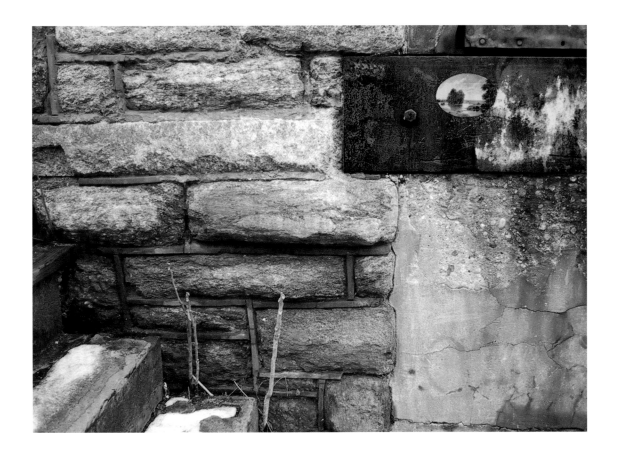

Trash receptacle at 256 West 108th Street at Broadway, Upper West Side, Manhattan

February 2001

This trash receptacle turned out to belong to a restaurant. I got caught by the restaurant's owner, but fortunately he liked the painting, so he told me that I could finish it. He was a watercolorist in his spare time and liked landscape paintings. We talked a lot about the relative difficulty of oil versus watercolor painting. I said that I thought watercolors are much more difficult because you can't fix your mistakes. Around lunchtime, he brought me a sandwich and some coffee.

The painting is based on Richard Wilson's painting of Croome Court and was still there when I was last uptown.

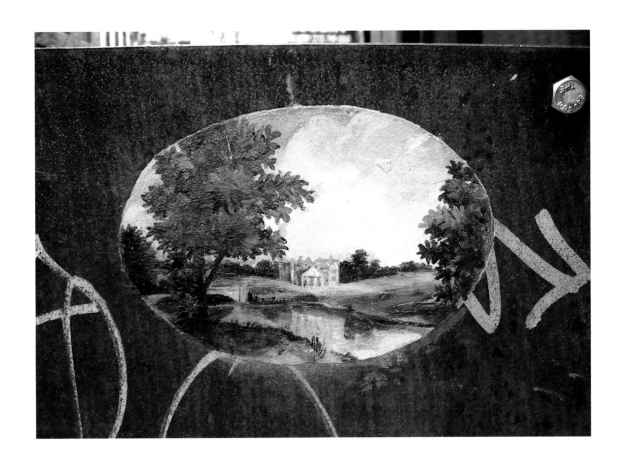

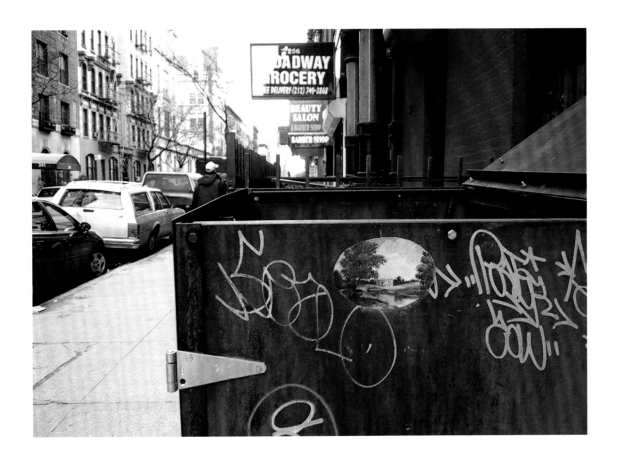

Container at 37 Commercial Street, Greenpoint, Brooklyn

February 2001

I picked this container because it had such nice graffiti. I don't know who the graffiti artist is. I've asked around but I couldn't find anyone who knows either. While I was painting, a father came by with his young son. They were walking their dog. The father told me that his son was artistic, which his son hotly denied.

The painting wasn't based on anything other than a desire to paint a sunset over the water, possibly because the container was so close to the water's edge. The container has been moved now, and I don't know where it is.

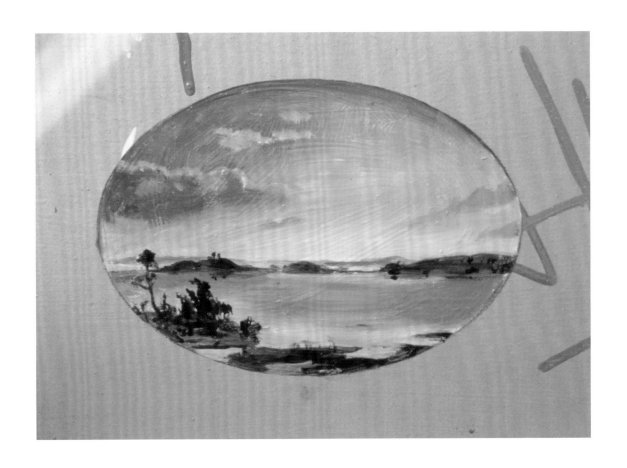

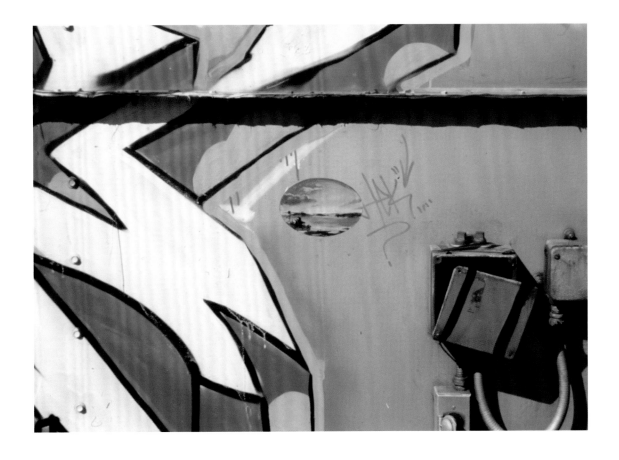

Fire alarm box at 24th Avenue and 27th Street, Astoria, Queens

February 2001

I made this painting for my friend Elizabeth Kaiden. She had just given birth and was living in Astoria and wanted an artwork that she could visit with her baby.

A lot of people stopped to talk while I painted this. Most of them seemed puzzled when I explained what I was doing. One man said, "You must have had a lot of practice." I agreed.

I like the old fire alarm boxes. Nowadays, no one would bother to decorate a thing like that. This painting is the one that Roberta Smith described as "one of the best" of the series in *The New York Times*. Unfortunately, I think she was reacting to the charm of the box rather than to the painting itself, which I made up, and which I don't think was entirely successful. I wished that the *Times* had picked another example. It was interesting that Roberta Smith described the paintings as being of the Hudson River School, as almost all of them were based on European landscape paintings, except, of course, for the ones that I made up.

I haven't been back in Astoria for a while, so I've no idea if the painting is still there.

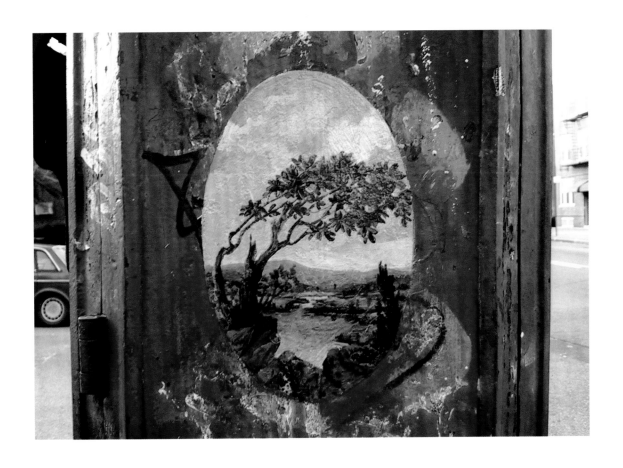

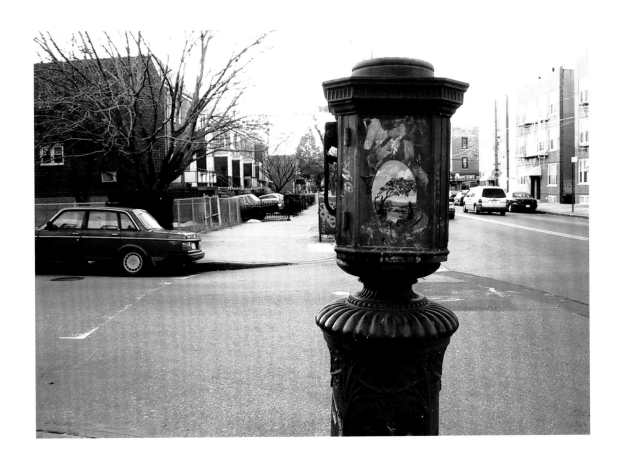

Staircase next to 118 East 1st Street between Avenue A and First Avenue, East Village, Manhattan

March 2001

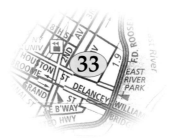

I made this painting for Jan Baracz, who lives next door to this staircase, after the first painting that I had made for him got painted over. The painting was based on Carl Rottman's *Sicyon with Corinth*. Jan took almost all of the digital photographs of this project, which we then edited together. He also designed the website and the map.

There is a pillow shop underneath the stairs, and the owner was curious about the project. He was very happy to have a painting, but he was worried that it would be painted over. He suggested fixing a glass plate over it so that it would survive, but I explained that the painting was meant to be ephemeral. He said that he couldn't see the point of that. When the painting got painted over half a year later, I wished I had taken his advice, because I liked this painting a lot.

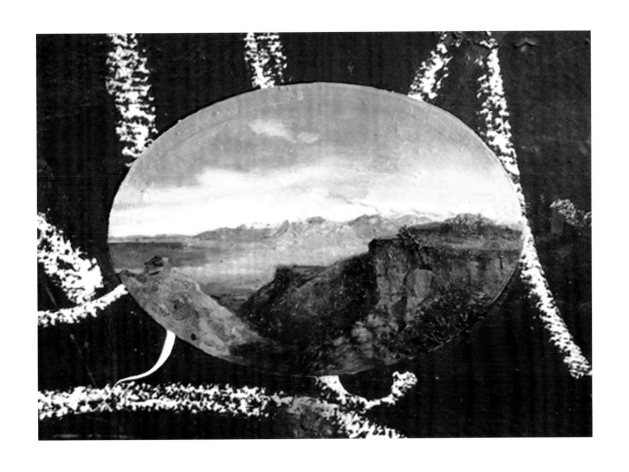

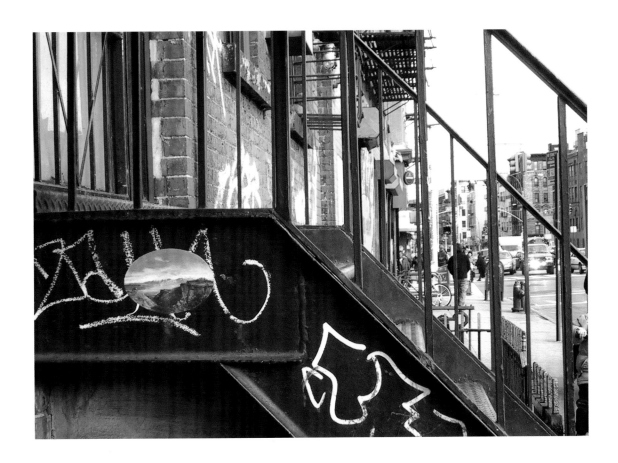

Container at the corner of Jackson Avenue and Orchard Street, Long Island City, Queens

March 2001

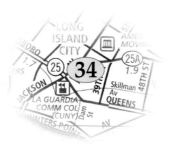

I picked this container because it was such a romantic pink color. The graffiti on the container said "Local 33," which I think must be a union. The container was in a parking lot that was deserted during the day, so I didn't meet anyone. There were a lot of pipes lying on the ground next to the container, so I had to balance on them while painting. I fell over a couple times. When I went back several months later, the container was no longer there.

I made the close-up of this painting into a postcard because I liked it so much. The painting is based on Richard Wilson's *Rome from the Villa Madama.*

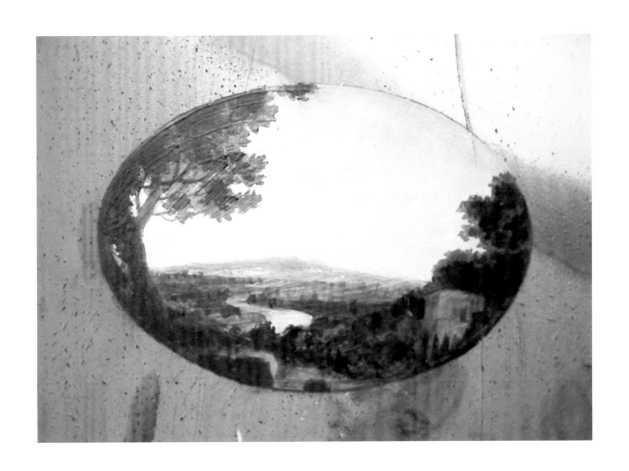

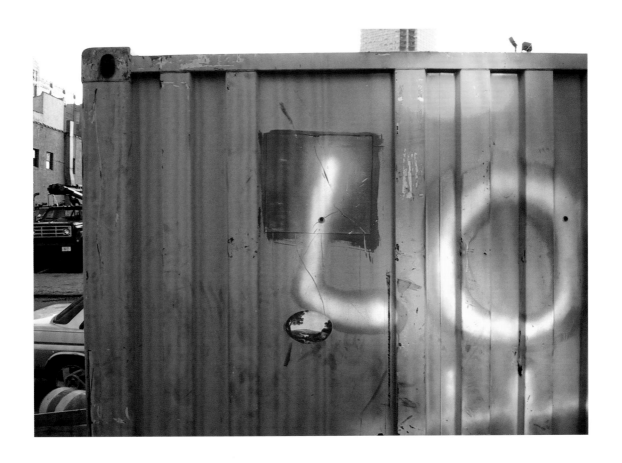

Skillman Avenue side of 414 Flushing Avenue, South Williamsburg, Brooklyn

March 2001

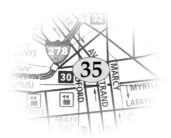

I wanted to paint in the Hasidic portion of Williamsburg, but it was too busy. People kept telling me to leave whenever I started to paint, so I did, because one of the rules of the project was that I would stop and restore the site if anyone objected. Generally, this wasn't much of a problem, because sites that already have a lot of graffiti are not very heavily defended. All that graffiti is there precisely because the site doesn't really belong to anyone; it's become a *de facto* public space.

No one ever asked me to stop painting once the painting became recognizable as a landscape. The most difficult part was always making the white underpainting, which was much less of a crowd-pleaser and which required several hours to dry. The first few hours before the landscape became recognizable were also often a bit tense. A lot of the fun of the project was finding nice, disorderly sites where you could spend several days painting illegally.

So this painting is a bit beyond the Hasidic section. I just kept driving in Williamsburg until I found this pleasingly deserted street. Nothing much happened while I painted because it was so deserted. Nothing much seems to have happened to the painting since I finished it either. It was still there when I last drove by.

This was my second version of Ludwig Richter's *Pond in the Riesengebirge*. I was unable to finish my first version in the Meatpacking District because of the police.

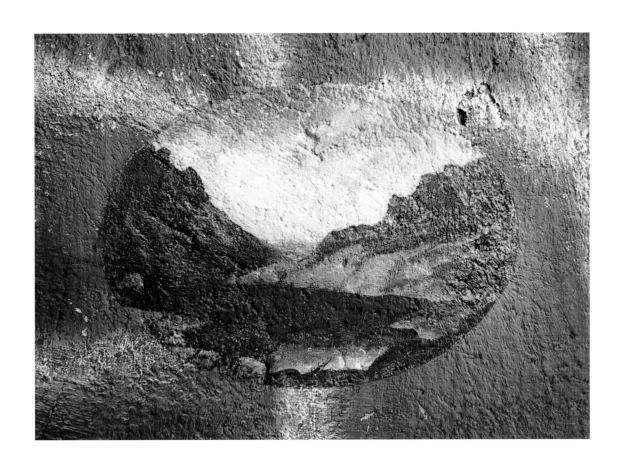

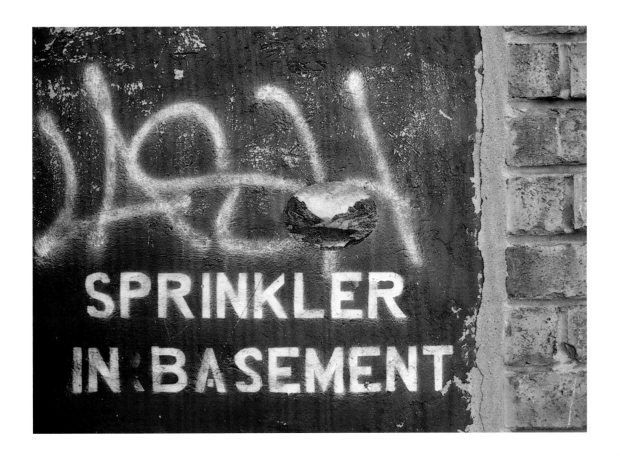

Abandoned building next to 994 Atlantic Avenue at Grand Avenue, Prospect Heights, Brooklyn

March 2001

This building is next to a car repair shop. When I started making the white underpainting, a man came out of the shop and said, "You from the city?" It turned out he thought the white oval had something to do with repairing the drains. I was sorry to disappoint him. He came back and brought me coffee. All through the day, he brought all of his clients over to meet me. Most of them asked if I was getting paid and were upset that I wasn't. I sympathized. There was also a consensus that the painting should be bigger and cover the entire wall, but I pointed out that that would be even more work for free.

This painting ended up on the cover of *American Letters & Commentary.* I think they chose it because the wall it was painted on had so many letters. I know they chose me because my infinitely more talented sister Matthea is their poetry editor.

I made the distance view of this painting into a postcard because I liked it. It's based on Johannes Flintoe's *Myrhorn, Jostedalen.* It was still there when I last looked, probably because the guy next door liked it so much.

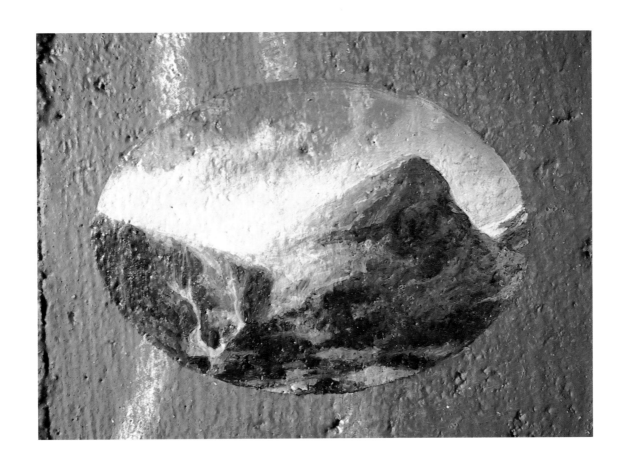

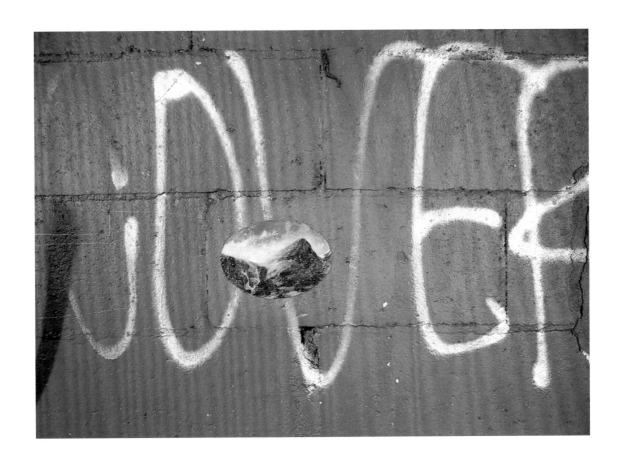

55 Berry Street between North 10th Street and North 11th Street, Williamsburg, Brooklyn

March 2001

This painting is very close to my house. It's painted on an old factory building. At the time, a lot of my friends lived and had studios there. Then it was sold for several million dollars, and now everyone has left. It's currently being renovated, but the renovations are taking a long time.

I painted over a poster. Over time, the poster faded. Now the poster is ripped off and my painting is gone with it. I showed the poster to Brad Downey, whom I met because he was making a movie about street art that he put me in. He told me that the poster was an art project, but that he couldn't remember the artist's name. I had assumed that it was for a band or something like that. Unfortunately, I look and sound completely ridiculous in the movie, which was called "Public Discourse by Darius and Downey." But it was entirely my own fault. When Brad and Quenell Jones came to film me they were great, but I was really nervous and it shows.

I made the close-up of this painting into a postcard because it was one of my favorites. It's based on Carl Rottman's *Taormina with Mt. Etna*, which I had also painted onto a traffic-control box where it was almost obliterated by a snowstorm. This was my replacement version.

Some German photographers who were working on a book about women artists and their gardens took a photograph of me in front of this painting for their book. I never saw the book, but I think I must have the smallest garden in it. I would have liked to get a copy for my mother, who is a landscape architect. The painting, along with photographs of paintings number 4, 6 and 24, also ended up in Kelly Burns's *INY*, a book of photographs of anonymous street art in New York City. In Kelly's photograph, the poster has faded entirely to gray. I never met Kelly, but I heard about his book from a friend who saw his photographs of my paintings in it.

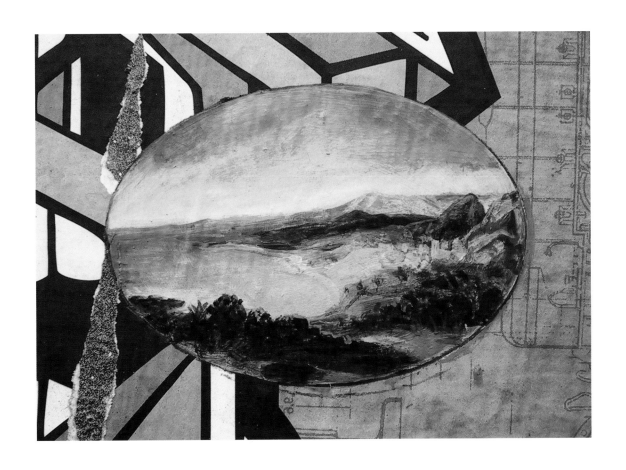

Wooden siding on East 59th Street between Lexington Avenue and Third Avenue,
Upper East Side, Manhattan

March 2001

This siding was just opposite Bloomingdale's, so I had to work very quickly because there were so many people. Fortunately, everyone was too busy to stop and talk or to look at what I was doing. I liked the idea of finding a graffiti site in such a visible place. You could tell that all the graffiti had been done very hastily. I don't think I would have been able to stand there for two days if I hadn't been a white woman or if I had been using spray paint. I think that what really upsets people and the authorities are the aesthetics of graffiti and the demographics of its practitioners. Of course, it's always talked about in terms of illegality, like the woman who wrote to *The New York Times* and said that I should be arrested for property damage.

When the Photography Committee from the Museum of Modern Art came by to visit the artists in the Studio Program at the P.S.1 Contemporary Art Center, several of the ladies from the committee had seen this painting. It disappeared eventually, along with the siding. The painting is based on a painting of Cader Idris by Richard Wilson.

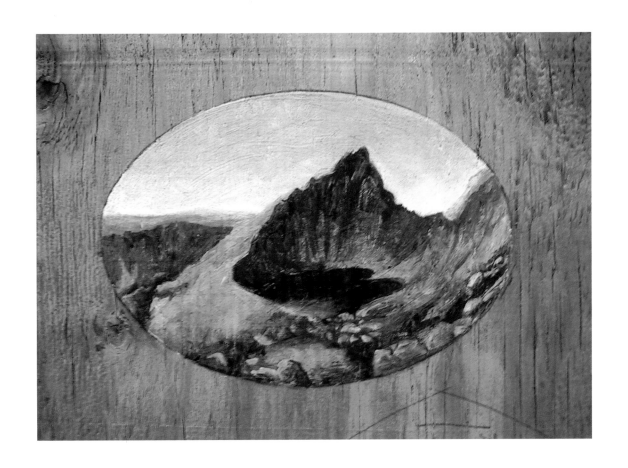

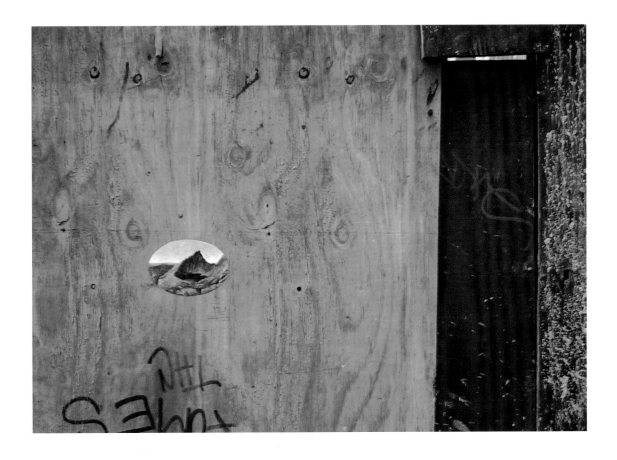

83

M line subway track support pillar No. M525C on Palmetto Street south of Seneca Street, Ridgewood, Queens

March 2001

By the time I showed photographs of the first fifteen paintings at GAle GAtes et al. in January 2001, I was getting tired of looking for sites. It's not so easy to find places where you can break the law, even in the most innocuous fashion. So I thought that I'd ask other people for suggestions. I also thought that it would be nice for people to be able to request paintings in their neighborhoods. So on the photocopied map that I made for the GAle GAtes show, I asked people to contact me if they knew of a site that they didn't own that needed beautifying.

Only one woman, who lived in Ridgewood, Queens, called me. She wanted me to paint something for her daily walk to the subway, which was under an overpass. While I was painting, several people who lived next to the overpass came by. They all liked the painting. One man offered me $50 to paint on his front door, but I had to explain that I wasn't doing commissions. The painting is still there, so we used it for the cover of this book. It's based on Charles XV's *Norwegian Landscape at Dawn*. As far as I know, he's the only monarch who was also an artist.

You can see my car in the photograph. It's an old Volvo. When *The New Yorker* wrote about the project in "The Talk of the Town," they titled their piece "Vandal in a Volvo," which is a bit embarrassing. Unfortunately, the day that Liesel Schillinger, who wrote the piece, came out with me, I got told off whenever I started painting and I didn't manage to find anywhere to paint. It's a lot easier to deal with people when you're by yourself. It may also have had something to do with the fact that I never got beyond the white underpainting that day. Little white ovals are just a lot less seductive than little oil paintings. So the article made it sound as though I encountered nothing but hostility wherever I went, when, in fact, the opposite was generally true. I liked the cartoon they did of me, though. I actually think the cartoon looks better than I do.

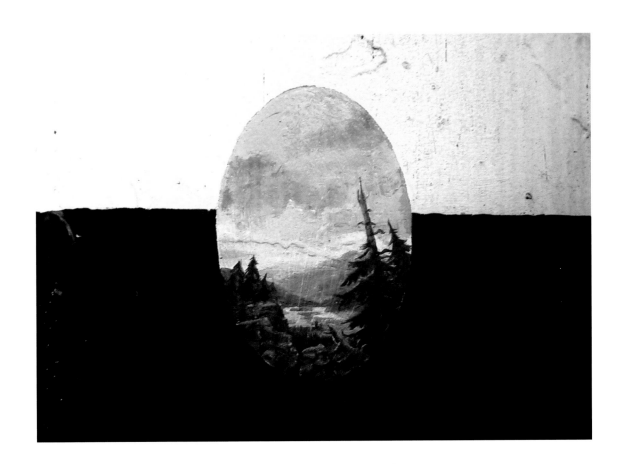

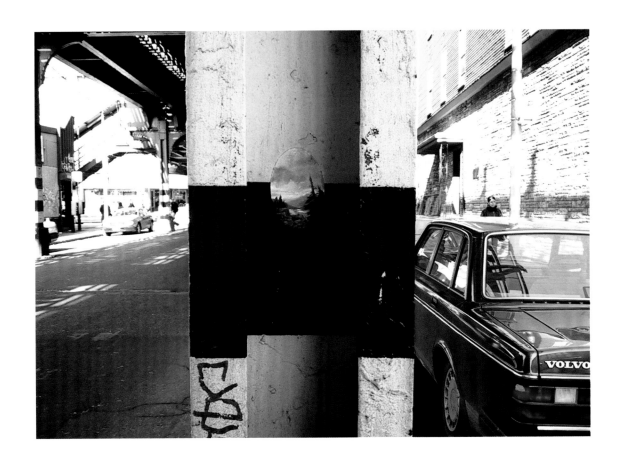

Location variable

May 2001

This one is a bit of a cheat because I did have permission to paint, which was against the rules of the project. But I just couldn't resist. And it was the last one.

The *Doris Moran* is an old eighty-foot tugboat that my friends Eve Sussman and Simon Lee bought and that was moored next to Metropolitan Lumber just south of the Williamsburg Bridge in Brooklyn. Whenever the weather was bad, they would have to bail her out so that she wouldn't sink. I felt sorry for them, so I offered to decorate the boat for good luck. To get onto her, you had to climb down the side of the dock, balance on a piece of floating lumber, and then climb up her side. I tried, but I was too scared to do it, and so I ended up making the painting once Eve and Simon had moved the boat to a more manageable dock in New Jersey.

For the shows at Apex Art and P.S.1, I photoshopped a pink oval with the words "to be completed" onto the side of *Doris* and used that as the last photograph. This was a bit of a mistake because it led to some people thinking that I had photoshopped all of the paintings onto photographs of the various sites, which was irritating after all of the trouble that I'd taken. So far, my favorite misinterpretation of the photographs is in a review of a show at Aljira in Newark by a New Jersey art critic who seemed to think that the project had consisted of my photographing old paintings, transferring the images onto stickers and then sticking the stickers over graffiti sites. I have no idea where he got this idea.

The painting is based on *Sunset on the Coast near Naples* by Joseph Wright of Derby. For a boat, I thought a nautical scene would be more appropriate than a landscape. *Doris* is sold now.

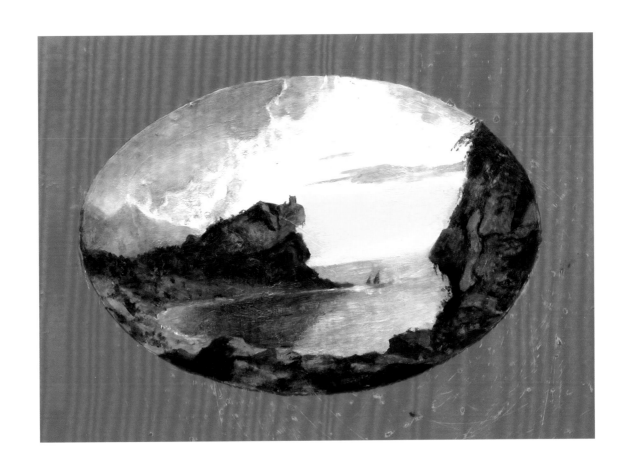

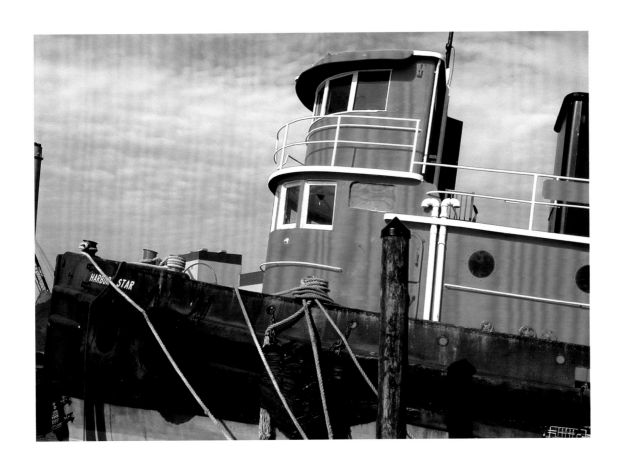

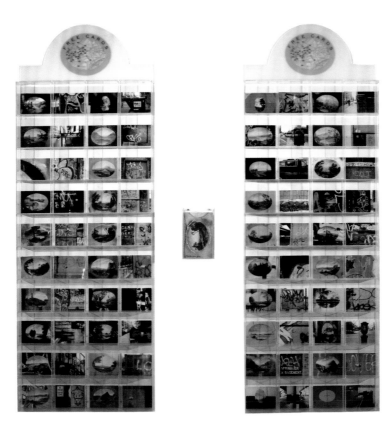

When I was done painting, I made postcards and a map of the project, just like any other New York attraction. I showed the postcards in plexiglass display cases that were made on Canal Street in one of the plastic shops there. They're about two feet wide and six feet high.

Acknowledgments

I would like to thank Greg Miller, not only for this book but also for all his friendship and support over the last ten years.

I would like to thank Jan Baracz for most of the photography of the project, the design of this book and more help and suggestions than I can begin to list.

Special thanks also to:

Aljira, Apex Art, the Artists Space Independent Projects Grants Program, the Austrian Cultural Institute, Regine Basha, the Bronx River Art Center, Thomas Buhl, Stacy Clarkson, Barbara Clausen, Laurie De Chiara, Tom Finkelpearl, GAle GAtes et al., Lucy Gallun, Michel Henri, Paulo Herkenhoff, Ana Finel Honigman, Karen Jones, Louisa Kamps, Moukhtar Kocache, Raina Lampkins-Fielder, Simon Lee, James Lewelling, Patrice Loubier, Peter Mattei, Mayday Productions, Shamim Momin, Sonke Müller, müllerdechiara, Dominique Nahas, Jacqueline Nathan, Sjur Nedreaas, the New York Restoration Project, Anne Pasternak, Postcard.com, the P.S.1 Contemporary Art Center, Lauren Ross, Daniel Schneider, Liesel Schillinger, Franklin Sirmans, Roberta Smith, Richard Stewart, William Stover, Stephan Stoyanov, Eve Sussman, Jonathan Weisberg, Brooke Williams and my parents, David and Margarete Harvey, my sisters, Celia and Matthea, and everyone who was kind to me on the streets.

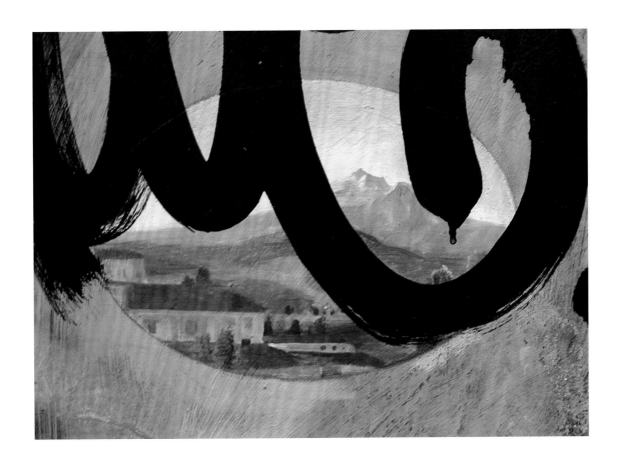

DATE DUE			